DEL MAR RACETRACK

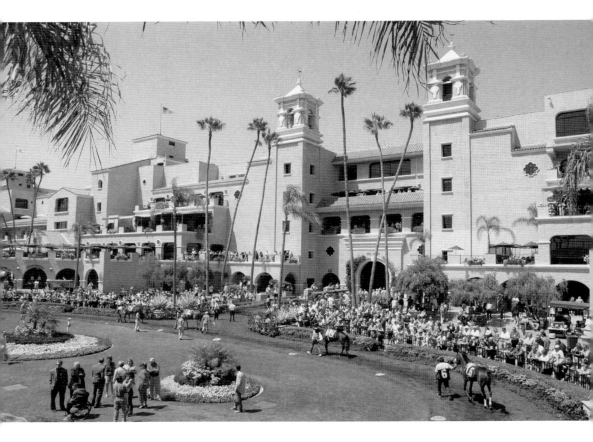

DEL MAR'S PICTURESQUE PADDOCK and Spanish Mission—style grandstand make for a fine photograph on a beautiful Southern California day. Note the thoroughbreds that are being paraded so the spectators along the fence can view them well. This is a highlight for many of the race fans. (Courtesy of Del Mar Thoroughbred Club.)

FRONT COVER: This is the first management team of the Del Mar Racetrack, from its inception in 1937 and throughout its informative years. The threesome pictured, from left to right, are general manager Bill Quigley, president Bing Crosby, and vice president Pat O'Brien. The lifestyle they created still endures today. (Courtesy of the Thoroughbred Club.)

COVER BACKGROUND: This is an aerial view of Del Mar Racetrack. (Courtesy of Bill Arballo.)

BACK COVER: The Thoroughbreds pictured here are driving to the wire through the stretch on the lush, green Jimmy Durante Turf Course at the Del Mar Racetrack. The lead horse is being strongly challenged, as evidenced by a contender at its right with a raised whip. But it is not discouraged, for it appears to be literally sailing through the air. (Courtesy of the Del Mar Thoroughbred Club.)

DEL MAR
RACETRACK

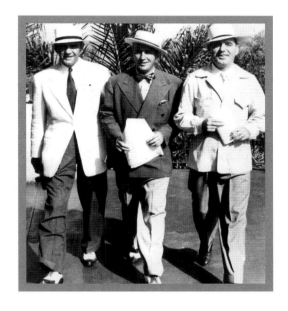

Kenneth M. Holtzclaw and the Del Mar Thoroughbred Club

ARCADIA
PUBLISHING

Copyright © 2006 by Kenneth M. Holtzclaw and the Del Mar Thoroughbred Club
ISBN 0-7385-3146-4

Published by Arcadia Publishing
Charleston SC, Chicago IL, Portsmouth NH, San Francisco CA

Printed in the United States of America

Library of Congress Catalog Card Number: 2006923326

For all general information contact Arcadia Publishing at:
Telephone 843-853-2070
Fax 843-853-0044
E-mail sales@arcadiapublishing.com
For customer service and orders:
Toll-Free 1-888-313-2665

Visit us on the Internet at www.arcadiapublishing.com

CONTENTS

ACKNOWLEDGMENTS

I am especially beholden to the Del Mar Thoroughbred Club during the preparation of this book. I first met C. P. (Mac) McBride, assistant director of media, at the Thoroughbred Club in mid-September, 2005. Together with McBride and Daniel G. Smith, director of media, we decided to do this book. Both media men were helpful throughout the process, and I appreciate their efforts in making this book a reality. My gratitude is also extended to Joe Harper, Del Mar Thoroughbred Club's president.

I further want to express my genuine thanks to Mr. and Mrs. Chase McCoy for their contribution of images for one of the chapters in this book. Chase and his wife, Doris, spent hours selecting photographs from the collection they acquired when they were active Thoroughbred horse owners and personal friends of John Longden and other race celebrities. My gratitude is extended to Bill Arballo of Del Mar for his contribution of vintage photographs for one of the book's chapters. Bill was Del Mar's third mayor and author of *Del Mar Reflections*, a book about his experiences growing up there. He continues to be active in many of Del Mar's events. And thanks to my wife, Margaret, for her encouragement and support.

INTRODUCTION

The 22nd District Agriculture Association (DAA) was in search of a permanent location for a fairground in 1933. For half a century, from 1880 to 1930, the fair was held in numerous temporary locations in Southern California and even suspended in 1930 because of the Depression. The fair board was revived, however, when pari-mutuel betting was legalized in California to help the economy recover. The newly organized DAA fair board president, James E. Franks, set out to establish a home for the fair that would be financed by the State Division of Fairs and Expositions. The Del Mar golf course was highly sought after for the fairground sight. Ed Fletcher, who was a senator in the state legislature at the time and represented the district that contained Del Mar, used his influence to establish the site in that city. He strengthened the possibility for its selection by promising assistance to obtain a Works Progress Administration (WPA) grant for construction of the fairgrounds. The fair board was convinced that the Del Mar site was an ideal location and, on October 7, 1935, it was announced by the San Dieguito Chamber of Commerce that the Del Mar golf course was the apparent winner. The fair board subsequently acquired 241 acres for the fairgrounds. WPA applications were submitted and, by January 23, 1936, grants were approved. Construction soon began, putting 380 men to work on the project daily, with an estimated construction time of nine months. The final stage of construction, after the fairground buildings were completed, was a mile-long, oval racetrack for harness racing, to be used at the fair the first year, and for Thoroughbred racing to follow.

When William Quigley of La Jolla heard the news that a fairground with a racetrack was coming to Del Mar, he immediately saw the possibility of starting major Thoroughbred racing there. He obtained a franchise to race on a verbal agreement with the fair board. Then he took the idea to Bing Crosby, who was breeding horses on his ranch in Rancho Santa Fe. Crosby supported Quigley's idea wholeheartedly and was instrumental in making the Del Mar Turf Club a reality. By May 5, 1936, articles of incorporation were filed, with Crosby as president of the board. On December 8, 1936, the Del Mar Turf Club obtained a 10-year lease for $100,000, with an option for an additional 10 years. Bing Crosby was granted a race permit for the track, and racing dates were set by the California Horse Racing Board—July 3 to August 7 each year. This represented a total of 22 days per season, with no racing on Sunday or Monday. Racing at the Del Mar Racetrack was now soundly on its way. The first race run at the Del Mar Racetrack was for two-year-old maidens, which included Bing Crosby's gelding, High Strike. It was an exciting battle, cheered on by many because it was being won by High Strike, the horse belonging to the track's founder. High Strike sailed across the finish line, the very first winner at the new track at Del Mar.

The Turf Club's lease expired in 1969, and an impressive new breed of owners, the Del Mar Thoroughbred Club, stepped forward and was awarded a 20-year lease by the state in 1970. Since then, Thoroughbred racing at Del Mar has steadily increased and is very successful today under the leadership of Joe Harper, Del Mar Thoroughbred Club's president.

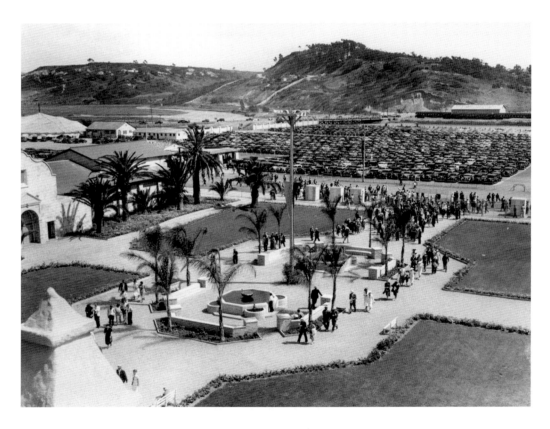

PICTURED HERE IS THE DEL MAR RACETRACK on July 3, 1937, opening day of its first 22-day meet. Cars behind the main grandstand entrance can be seen packed into the small parking lot. About 15,000 people showed up for this first meet, and cofounders Bing Crosby and Pat O'Brien were on hand at the turnstiles to meet early arrivals. (Courtesy of Del Mar Thoroughbred Club.)

EARLY DEL MAR RACING

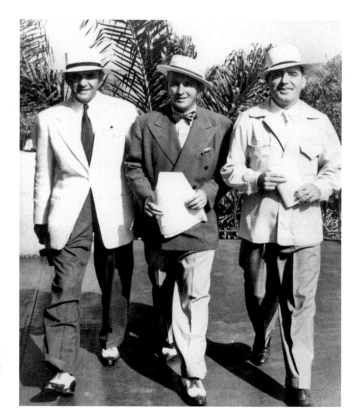

SHORTLY AFTER BING CROSBY moved to the Don Osuna Ranch in Rancho Santa Fe, he and a few Hollywood cronies organized the Del Mar Turf Club, signing a 10-year lease with the 22nd District Agricultural Association, and the rest is history. Pictured here, from left to right, is the early management team of the Del Mar Racetrack: general manager Bill Quigley, president Bing Crosby, and vice president Pat O'Brien. (Courtesy of Del Mar Thoroughbred Club.)

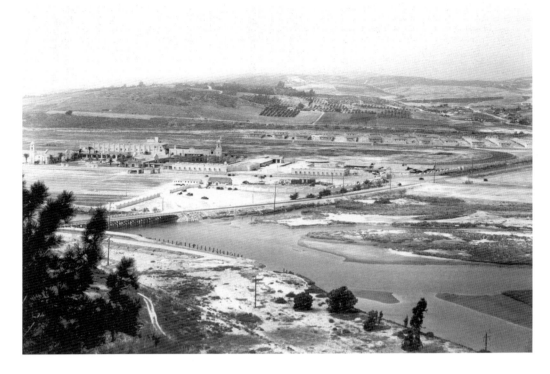

THIS IS AN EARLY VIEW of the Del Mar Racetrack, photographed from a hill elevation to the southeast. In the foreground, the San Dieguito River passes under the bridge that leads back to the town of Del Mar to the south. Note the pristine landscape in the distance, quite remote from the multiple structures that cover the territory today. (Courtesy of Del Mar Thoroughbred Club.)

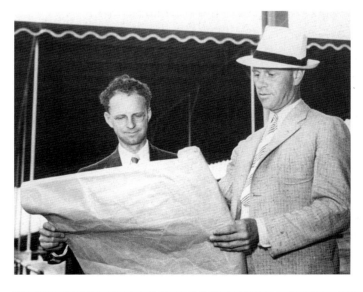

SAN DIEGO ARCHITECTS Sam Hamill, left, and Joe Hamill are pictured here holding plans of the racetrack stadium. Along with Herbert Louis Jackson, it was their inspiration that brought forth the Spanish motif of the stadium. The project was partially financed by federal Works Progress Administration funds and later by the private funds of Crosby and O'Brien. (Courtesy of Del Mar Thoroughbred Club.)

THE OSUNA ADOBE can be seen through this large gateway on the hill above. The adobe was built in 1845 by Juan Osuna and still stands today at Via de la Valle. It passed through various owners in the ensuing years. In 1932, Bing Crosby purchased the adobe, along with 50 acres, and had Lillian Rice design an additional house that would blend in with the adobe. (Courtesy of the author.)

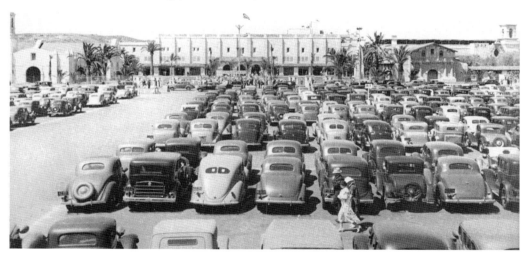

THE PARKING-LOT SCENE depicted here could have been taken on opening day as a large crowd showed up for the race. By the time the first 22-day meet, starting on July 3, 1937, came around, the stadium was essentially finished, although it was alleged that some of the paint was still not dry. The racehorses, however, were ready and willing to run. (Courtesy of Del Mar Thoroughbred Club.)

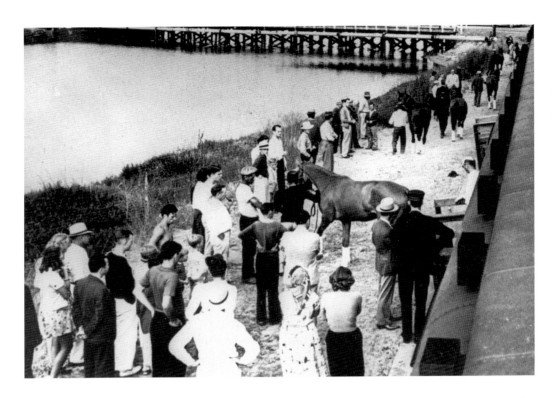

THIS PHOTOGRAPH SHOWS a number of both fans and racehorses that have arrived by Santa Fe Railway train and are making their way to the racetrack. The Thoroughbreds, as well as many of the fans, arrived daily at Del Mar by train to attend the races. Note the casual stance of some fans as they ponder the beauty of one of the new Thoroughbred arrivals. (Courtesy of the Del Mar Thoroughbred Club.)

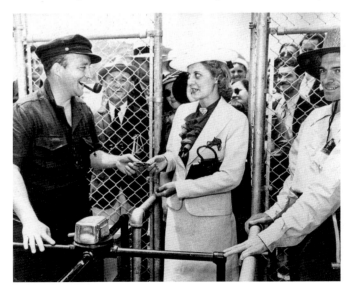

MRS. W. R. RICHARDSON made history on opening day—she was the first patron through the gates. She is pictured here presenting her ticket to Bing Crosby, who was cheerfully manning the turnstile adorned in his familiar floppy sports shirt and yachting cap. The first race was late in starting because the Santa Fe Railway had not allowed enough time for loading the racehorses. (Courtesy of Del Mar Thoroughbred Club.)

EARLY DEL MAR RACING

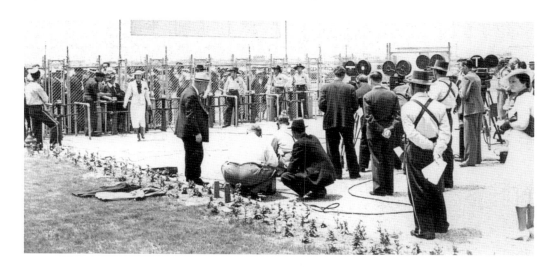

MRS. W. R. RICHARDSON is walking from the turnstile just after she was admitted to the stadium grounds by Bing Crosby. She was greeted by a parade of newsreel cameramen recording the historic Del Mar Racetrack event as the gates to the track opened for the first time on Saturday, July 3, 1937. (Courtesy of Del Mar Thoroughbred Club.)

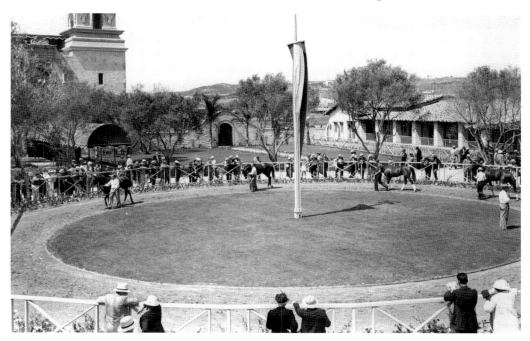

THE WALKING RING established at Del Mar Racetrack is pictured here at its early inception. Before each race, the thoroughbreds were taken to the paddock, made ready for the race, then led out to the walking ring and circled so the prospective wagerers could get a good eye-to-eye look at the horses running in the next race. (Courtesy of Del Mar Thoroughbred Club.)

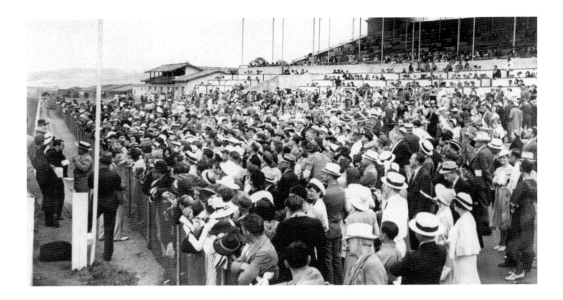

BING CROSBY, AT LEFT, is wearing a familiar hat and smoking his trademark pipe. On opening day, he mingled with race fans before the first race, which did not start on schedule due to the belated train that carried the plungers from Los Angeles to the race. Finally everyone cheered the oncoming train, as they eventually did the first race. (Courtesy of Del Mar Thoroughbred Club.)

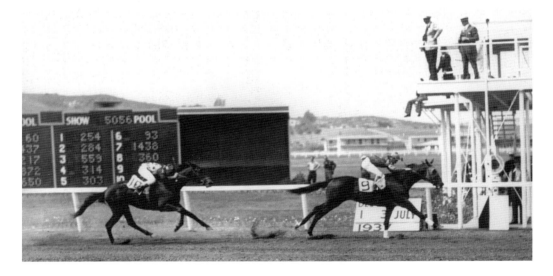

THE TRAIN DELIVERING THE THOROUGHBREDS for the first race arrived late. When it appeared, coming through the hills to the north, everybody cheered. Pictured is gelding High Strike, winning the belated first race on opening day. The horse was owned by Bing Crosby, which caused suspicion for some. The crowd, however, cheered profusely. (Courtesy of Del Mar Thoroughbred Club.)

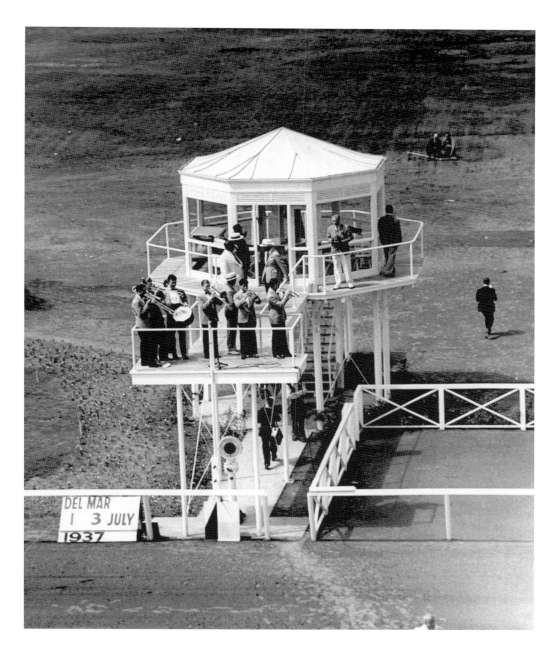

PICTURED IS THE STEWARDS' STAND in the infield, with the date of the first race of the first 22-day meet posted out front. Opening day was a special one for the Del Mar Racetrack, and a band set up on the stewards' stand in the infield helped entertain the big crowd on this day in 1937. (Courtesy of the Del Mar Thoroughbred Club.)

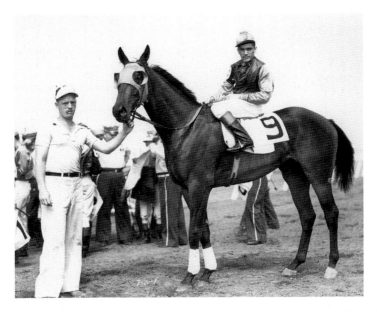

JOCKEY JACKIE BURRILL proudly poses atop the winner of the first race, High Strike. There was no elaborate winner's-circle celebration, as seen in many of today's race finishes, but the elation of winning this race was certainly as intrepid as many that have followed. The winner's-circle ceremony eventually evolved after other race wins. (Courtesy of Del Mar Thoroughbred Club.)

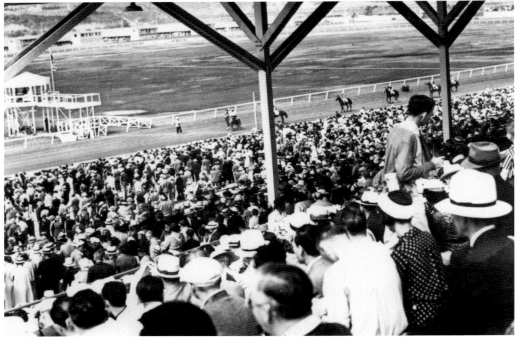

PICTURED HERE IS THE BEGINNING of the parade to the post on an afternoon during Del Mar Racetrack's first season in 1937. The grandstand and open area in front appear to be filled to capacity. Hats were much in vogue for the race crowd, as evidenced here. Note the remote, barren infield, in contrast to today's scene. (Courtesy of Del Mar Thoroughbred Club.)

EARLY DEL MAR RACING

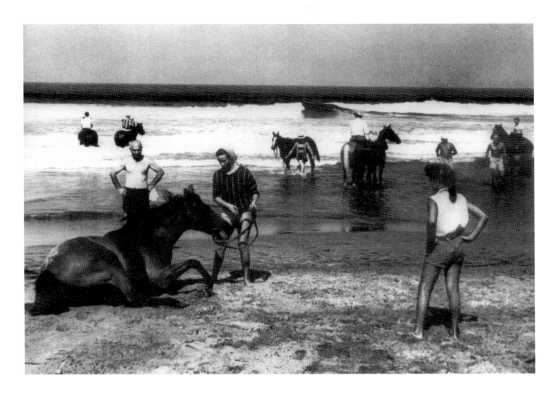

IN THE EARLY YEARS OF RACING, it was quite common to take the Thoroughbreds out to the Pacific shore and let them enjoy walking through the surf. Here a number of horses were brought to the beach and are enjoying the water at the mouth of the San Dieguito River, c. 1960. (Courtesy of Bill Arballo.)

BARBARA STANWYCK AND ROBERT TAYLOR were among the many Hollywood stars in attendance on opening day in 1937. Bing Crosby made it a point to bring on board as many stars as possible for this opening day by highly publicizing it in Hollywood. Many thought this to be a gala event they had to attend. (Courtesy of Del Mar Thoroughbred Club.)

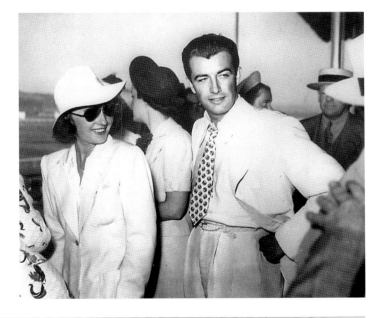

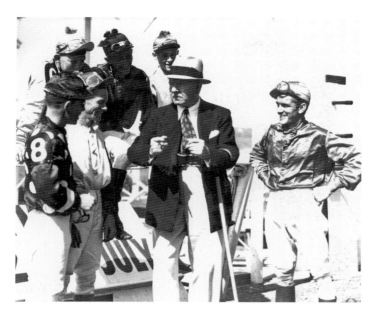

IT HAS BEEN SAID that W. C. Fields could lure a crowd almost everywhere he went. Here he is seen encircled by a group of jockeys at Del Mar, all who appear to be highly engrossed in his storytelling and joking, for which he was most popular. Witnessed by the smiles on their faces, his spiel must have come across most successfully. (Courtesy of Del Mar Thoroughbred Club.)

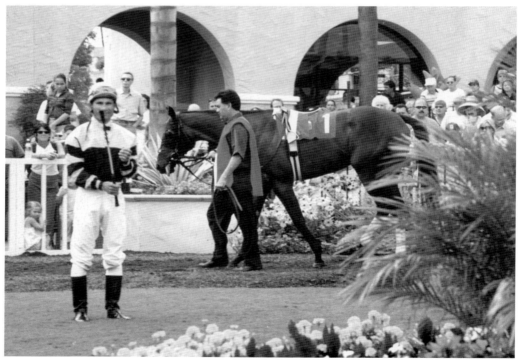

THIS PADDOCK SCENE is awash in color, from the flowers surrounding the paddock to the jockey's silks. Visiting the paddock prior to the beginning of a race is important to many race fans. They like to view the horses, and it is alleged that some actually base their wagering on a horse's beauty and apparent stamina. (Courtesy of Del Mar Thoroughbred Club.)

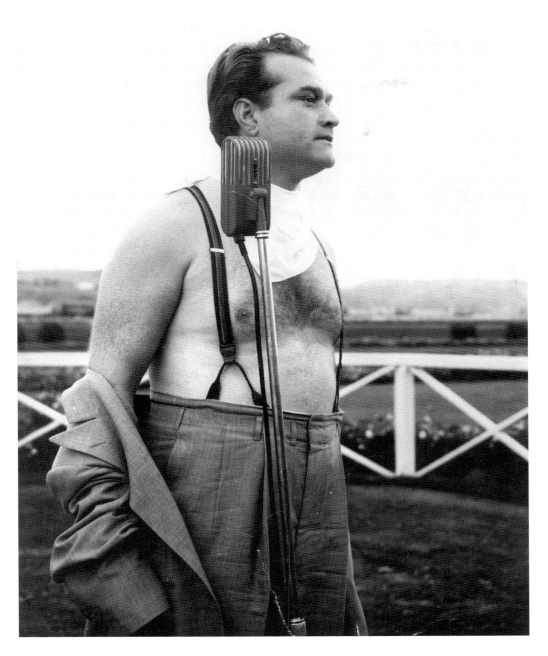

MANY OF YESTERYEAR'S STARS were busy advancing their careers and felt it prudent to come to large events like opening day at Del Mar. Red Skelton was perhaps one of the most popular comedians present, and he made his presence known. Pictured here shirtless, he jovially makes it clear to the entire crowd that he bet on the horses and lost his shirt. (Courtesy of Del Mar Thoroughbred Club.)

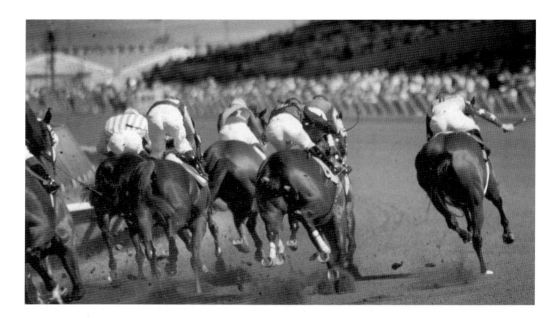

IN THIS RACE, the horses are bunched together as they turn for home at the top of the stretch, where the roar of the crowd becomes louder. This is the point where the race fans usually stand up in order to get the best possible view of the front-runners. Then there is the clapping of hands or turning away in disgust, depending upon the outcome of the race. (Courtesy of Del Mar Thoroughbred Club.)

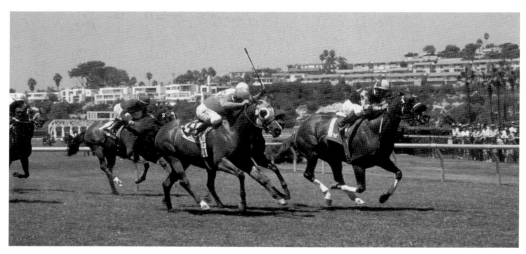

THE THOROUGHBREDS PICTURED HERE are driving to the wire through the stretch on the lush, green Jimmy Durante Turf Course at Del Mar. The jockeys on the four bunched horses in the lead are giving it their all, while the lead horse, being strongly challenged by several contenders, appears to literally be sailing through the air. (Courtesy of Del Mar Thoroughbred Club.)

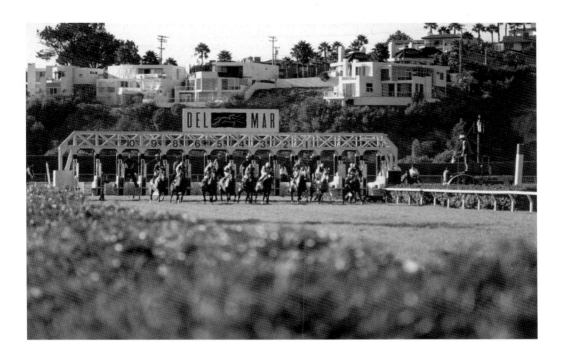

IN THIS PHOTOGRAPH, they are off and running down Del Mar's infield chute on the Jimmy Durante Turf Course. This state-of-the-art course has been fully reseeded with GN-1 Bermuda grass. It previously consisted of a combination of Coast Bermuda, Hybrid Bermuda, and Kikuyu grass, all with different growing patterns and watering requirements, making it hard to manage. (Courtesy of Del Mar Thoroughbred Club.)

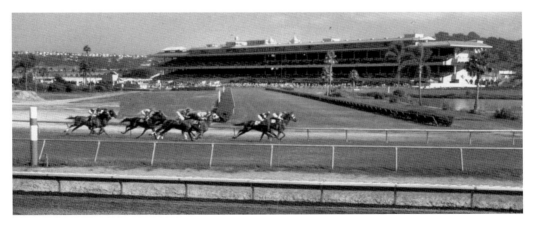

THE FIELD MAKES ITS RUN through the far turn on the turf at Del Mar, with the grandstand in the distance framing the action. The crowd in the grandstand, at near-full capacity, anxiously awaits the outcome of the race, and many would hover close to the rail in front of the grandstand. Note the dirt course in the foreground. (Courtesy Del Mar Thoroughbred Club.)

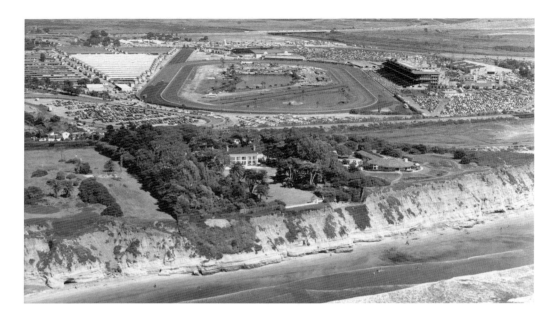

THERE IS NO BETTER WAY to view the overall area of the Del Mar Racetrack than by an aerial view like the one here, taken from the west. It clearly and quite distinctly shows the Del Mar Racetrack's proximity to the Pacific Ocean shoreline. The popular song, "Where the Turf Meets the Surf Down in Old Del Mar," becomes an actuality here. (Courtesy of Del Mar Thoroughbred Club.)

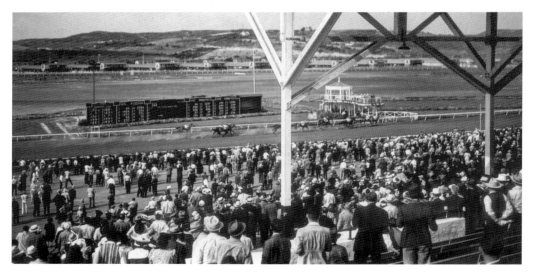

THIS PHOTOGRAPH DEPICTS RACING through the stretch as seen from the original grandstand built for the track's opening in 1937. The early grandstand served its purpose well for a number of years, but as time passed and racing promoted much larger crowds, the building of a more modern structure was deemed necessary. (Courtesy of Del Mar Thoroughbred Club.)

EARLY DEL MAR RACING

A GROUP OF EXERCISE RIDERS takes out a string of Thoroughbreds to stretch their legs on an early Del Mar morning. Outings like this were important to keep the horses in good physical shape and promote activity. In early years, these riding jaunts were often done on the nearby beach, making them very pleasant. (Courtesy of Del Mar Thoroughbred Club.)

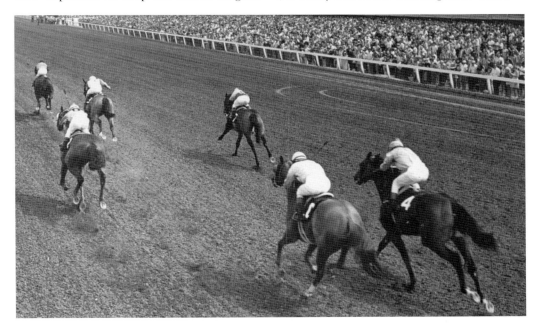

A BIG HOLIDAY CROWD takes in the stretch action in this 1960s shot, with the stadium and front viewing area apparently filled to nearly full capacity. From the appearance of the photograph, it is quite apparent that great weather provided a beautiful day for race fans. Days like this make the races at Del Mar a very pleasant experience. (Courtesy of Del Mar Thoroughbred Club.)

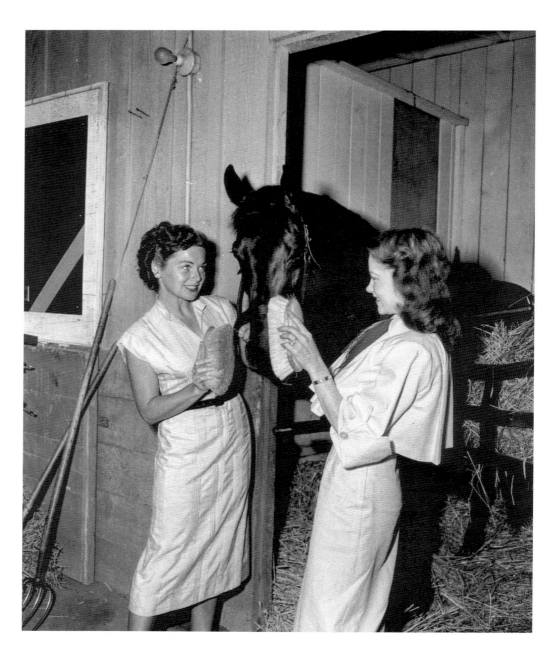

THIS POSED 1950 PHOTOGRAPH shows a pair of cuties making sure their favorite Thoroughbred has a shiny coat. Brushing is an important routine in the stable area; it not only keeps the horse looking its best but also comforts the animal. This Thoroughbred seems to be enjoying the attention. (Courtesy of Del Mar Thoroughbred Club.)

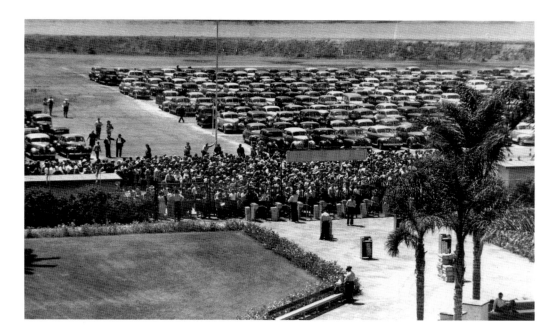

WITH A FULL PARKING LOT in the background, this crowd awaits for the gates to open to the race grounds on opening day in 1937. The vintage cars in the parking lot can be seen in many antique auto shows today. (Courtesy of Del Mar Thoroughbred Club.)

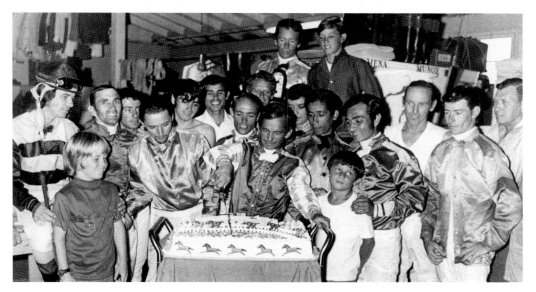

AT HIS BIRTHDAY PARTY, Hall of Famer Bill Shoemaker cuts the cake in the jockey room with help from the boys. His apparent popularity is due to the numerous fellow jockeys who have turned out for his birthday celebration. The large horse-decorated cake brought smiles to some. (Courtesy of Del Mar Thoroughbred Club.)

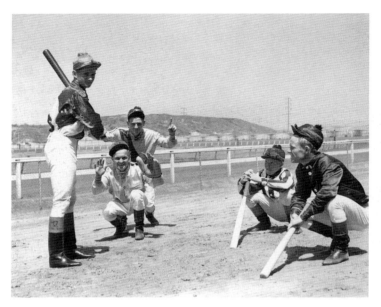

RIDING HORSES wasn't the only thing the jockeys did during those first few seasons at Del Mar. Pictured here are several jockeys during a ballgame on the Del Mar Racetrack grounds. Playing baseball was a popular sport around the track during this time. It provided the jockeys with great exercise to keep fit and offered a reprieve from racing. (Courtesy of Del Mar Thoroughbred Club.)

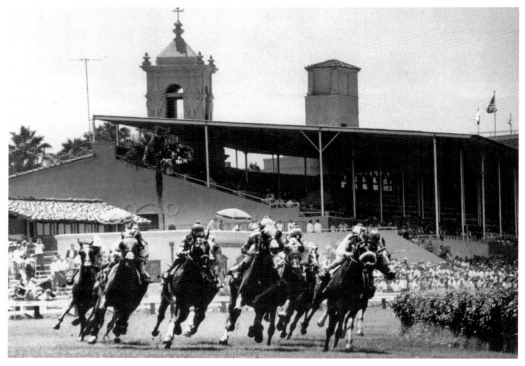

THE RACE IS ON. They have left the gate and are pictured making the run into the clubhouse turn on the Jimmy Durante Turf Course at Del Mar. Now the excitement of the race begins. Binoculars are lifted and the fans try to follow their pick. Some fans prefer to watch turf races. (Courtesy of Del Mar Thoroughbred Club.)

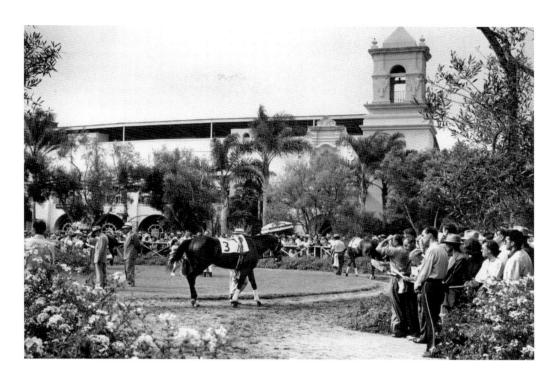

PICTURED HERE IS THE PADDOCK at the Del Mar Racetrack in the early years, one of the prettiest in all of horse racing. Today it stands out as the most beautiful site around the Del Mar Racetrack grounds. Many fans spend much of their time in this area, with its garden setting and the activity of the Thoroughbreds passing by. (Courtesy of Del Mar Thoroughbred Club.)

PICTURED HERE TRACKSIDE in 1938 are general manager William Quigley (right) and actors Kitty Kelly and Donald O'Connor, at an early age in his career. Towering above them, atop the stadium roof, is the small NBC facility where, at times, Bing Crosby's popular radio show was broadcast, giving a plug to the racetrack. (Courtesy of Del Mar Thoroughbred Club.)

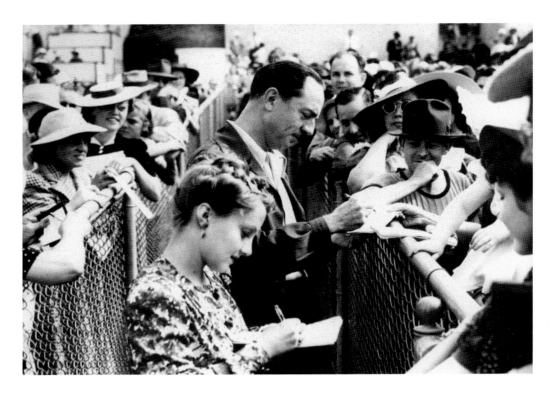

WILLIAM POWELL AND HIS WIFE, Diana Lewis Powell, are busy signing autographs for Del Mar fans. William Powell's movies made him famous during this era, but the *Thin Man* series, with Myrna Loy, and the devoted fans of the series propelled him to the forefront. His popularity at Del Mar often brought forth crowds like this. (Courtesy of Del Mar Thoroughbred Club.)

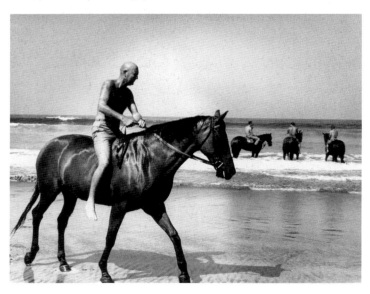

CHARLIE WHITTINGHAM works his horse on a Del Mar beach, where he often would stride through the shallow waves. He believed that saltwater was good for the horse's legs. After he won the Caliente Handicap in Tijuana, a lot of Del Mar horsemen started taking their horses to the beach, which was a real spectacle for the crowds there. (Courtesy of Del Mar Thoroughbred Club.)

EARLY DEL MAR RACING

PICTURED HERE, from left to right during the 1937 race season, are Bing Crosby's three sons—Gary and twins Dennis and Philip. Philip has evidently been introduced to the flashbulb of the camera, evidenced by his closed eyes. Crosby's sons learned about horses early in life, often watching them being paraded in the walking ring at Del Mar and observing those back on the ranch at home. (Courtesy of Del Mar Thoroughbred Club.)

DEL MAR PRESIDENT BING CROSBY and director C. S. Howard had a lot to look forward to in the summer of 1938. Crosby's horse, Ligaroti, and Howard's horse, Seabiscuit, would meet in a match race that summer, as conferred earlier in the year. Both horses were top-rated, and the anxiety of which one would be the winner was certainly in the air. Crosby's horse was owned in partnership with Lin Howard, C.S.'s son. (Courtesy of Del Mar Thoroughbred Club.)

PICTURED HERE, SEATED at a Turf Club table, are Bing's wife, Dixie, in her wide, white-brim hat; his mother, Kate; and Bing's father, Harry L. Crosby Sr. The races at Del Mar were often anxiously anticipated events, and a day at the races was considered a family affair for the Crosbys. Many fans looked forward to greeting them there when they came. (Courtesy of Del Mar Thoroughbred Club.)

PAT O'BRIEN is out on the Del Mar track, driving a tractor and working the grounds. He was always ready and willing to jump in and tackle almost any job that needed to be done around the grounds, and while he was quite adept with these jobs, he never let it interfere with the duties required or demanded by his vice presidency. (Courtesy of Del Mar Thoroughbred Club.)

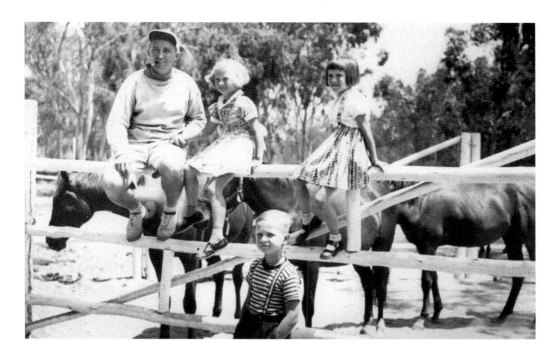

BING CROSBY SITS on a fence rail that stabled his horses on his ranch in Rancho Santa Fe, not far from the track. He is accompanied by children from an orphanage, who he was hosting. The eucalyptus trees in the background, a residual of the thousands once planted by the Santa Fe Railroad for wood and railroad ties, still remain. (Courtesy of Del Mar Thoroughbred Club.)

THIS PHOTOGRAPH portrays Don Ameche, left, casually talking to Pat O'Brien during one of his visits to the Del Mar Racetrack. Ameche was a versatile and popular film actor in the 1930s and 1940s. He was also a popular radio master of ceremonies, being inducted into the Radio Hall of Fame in 1992. Pat O'Brien was happy to welcome him. (Courtesy of Del Mar Thoroughbred Club.)

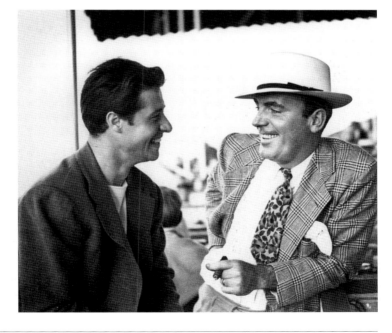

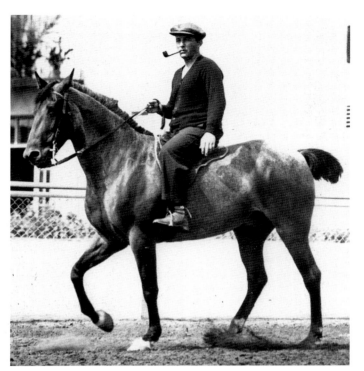

BING CROSBY NOT ONLY LIKED owning horses, he also enjoyed riding them. Here is a familiar scene at Del Mar in the early years—Bing riding in his usual style, casually loping along and smoking his familiar trademark pipe. It was the highlight for any fan visiting the track to be near such a scene and witness one of these casual rides. (Courtesy of Del Mar Thoroughbred Club.)

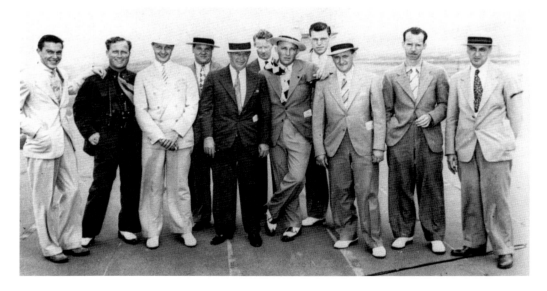

MEMBERS OF THE PRESS CORPS, from left to right, posing for a photograph with Bing Crosby, are Hayden Ingalls, Oscar Otis, Duke Lindeman, Maurice Bernard, Bill Roderrick, Mike Mahorney, Frank Haven, George Herrick, Harry Hache, and Moody Corper. The legendary press party began on opening day and survived beyond the Crosby days. (Courtesy of Del Mar Thoroughbred Club.)

EARLY DEL MAR RACING

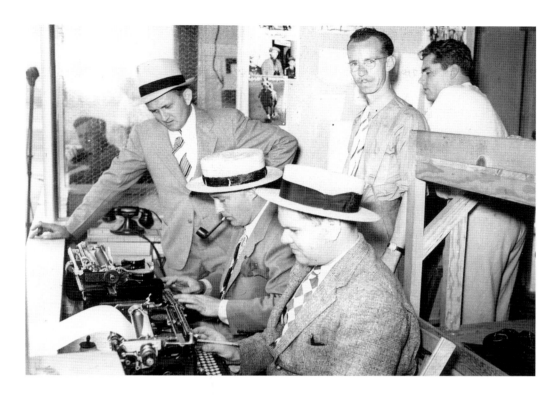

BING CROSBY WAS NOT always laid back and casual. When there was work to do, he was there to do it. Here he has borrowed a typewriter from *San Diego Tribune* sports editor George Herrick, standing at his shoulder, who is visiting the press box. In the foreground is turf writer Maurice Bernard, and standing behind them is Harry Hache of the *San Diego Union* newspaper. (Courtesy of Del Mar Thoroughbred Club.)

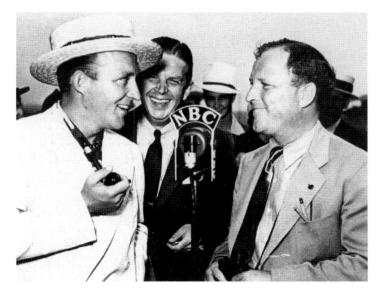

BING CROSBY IS PICTURED HERE with announcer Ken Carpenter, center, and visitor Oscar Otis, at right. NBC's Kraft Music Hall, starring Bing Crosby, was broadcast directly from Del Mar in 1937. With a pipe in hand, Crosby has evidently given some jovial commentary based on the hearty smiles that abound around the NBC mike. (Courtesy of Del Mar Thoroughbred Club.)

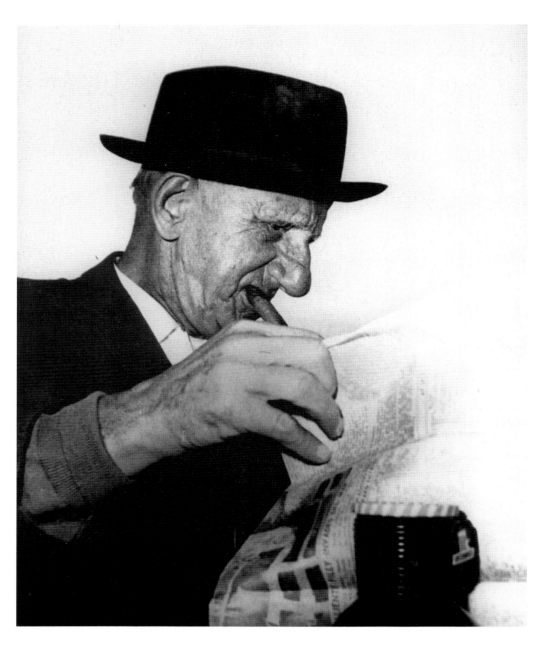

JIMMY DURANTE IS PICTURED at Del Mar smoking his familiar cigar and intensely searching the paper for a winner. A favorite at press parties, his antics were legendary and usually included dismantling a trick piano as part of his act. Once he forgot to bring his trick piano and demolished a nearby real one. The track bought the piano. (Courtesy of Del Mar Thoroughbred Club.)

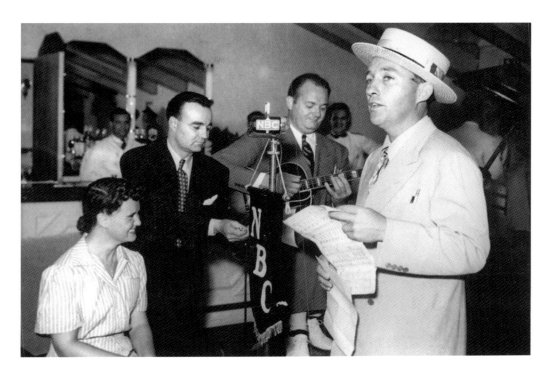

BING CROSBY, backed by guitarist Perry Bodkin, serenades listeners on the most popular show in America—the Kraft Music Hall on NBC. The network broadcast the half-hour show every Saturday morning from Del Mar. It was in this year, 1938, when the wife of one of Crosby's writers coined the phrase, "Where the turf meets the surf." (Courtesy of Del Mar Thoroughbred Club.)

AVA GARDNER AND HER SISTER enjoy a day at the races. Her sister, left, appears to have made a selection from the race program, and Ava is looking on with interest. Starring in numerous movies, Ava, whose career spanned filmography from the early 1940s to the 1980s, welcomed a day at Del Mar where she could divert from the stress of Hollywood. (Courtesy of Del Mar Thoroughbred Club.)

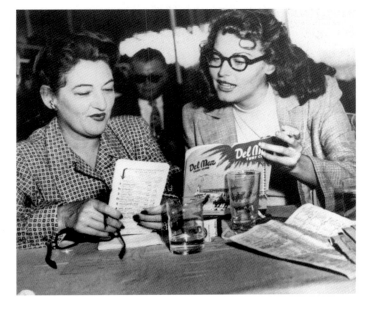

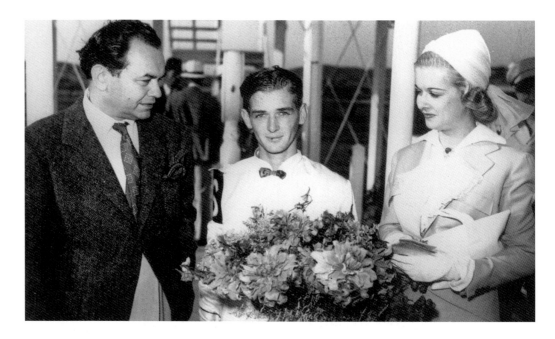

In 1937, actor Edward G. Robinson and actress Joan Bennett congratulate jockey Owen Webster after he won the Coronado Handicap on Boss Martin. Jockeys were often honored in this manner after a win at an important race, such as a featured handicap race. This was a rare appearance for both Robinson and Bennett and a great honor for jockey Owen Webster. (Courtesy of Del Mar Thoroughbred Club.)

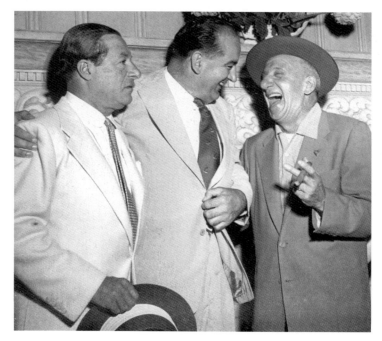

PICTURED HERE ARE three personalities that met together one day at the Del Mar Racetrack in 1938. George Jessel (left), actor, producer, composer, and writer of filmography, appears to be unimpressed by the jovial laughter of Jimmy Durante and Senator McCarthy. Jimmy was a regular at the track, but this was a rare visit by Sen. Joseph McCarthy. (Courtesy of Del Mar Thoroughbred Club.)

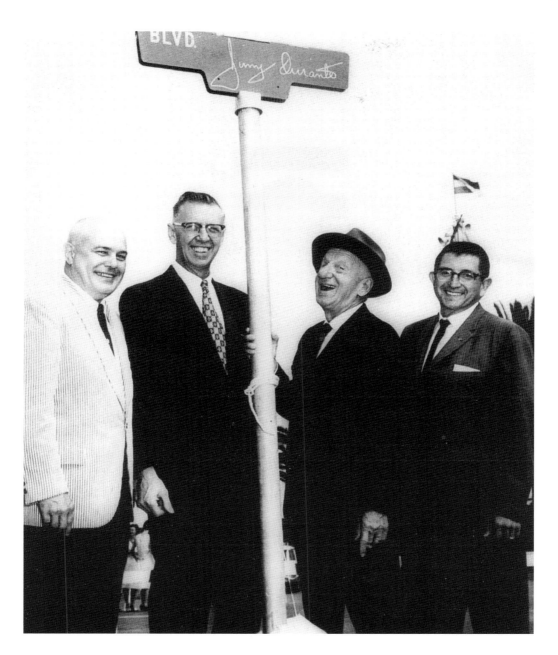

THE DEDICATION OF Jimmy Durante Boulevard was an exciting day for many residents of Del Mar, as well as for the San Diego Fairgrounds and the Del Mar Racetrack. Pictured here, from left to right, are fair manager Bob Jones, Mayor Vic Koss, Jimmy Durante, and deputy mayor Bill Arballo. (Courtesy of Bill Arballo.)

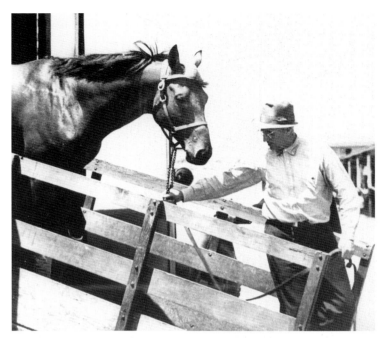

TRAINER TOM SMITH leads handicap Seabiscuit from the van on arrival at Del Mar. Over 20,000 fans showed up for the match race between Seabiscuit and Ligaroti. Crosby and O'Brien were stationed behind a microphone on the roof of the grandstand to broadcast the result to a nationwide audience. (Courtesy of Del Mar Thoroughbred Club.)

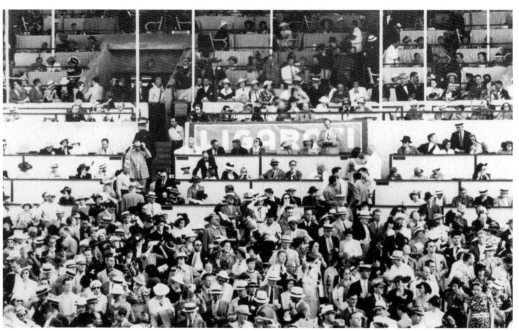

THERE WAS A SIGNIFICANT-SIZED fan club for Ligaroti, and a large sign with the horse's name was displayed at a box under the stadium. Many believed Bing Crosby's horse was a sure win, but it was to be disproved with the great upset, a disappointment to Bing Crosby and the many fans of Ligaroti. (Courtesy of Del Mar Thoroughbred Club.)

This is a head-on action shot of Seabiscuit in an early-morning workout in preparation for his duel with Ligaroti. After Seabiscuit won this race, he went on to greater glory that year, upsetting War Admiral, the champion of the East, in a victory at Pimlico on November 1. He capped his great career by finally winning the Santa Anita Handicap in 1940. (Courtesy of Del Mar Thoroughbred Club.)

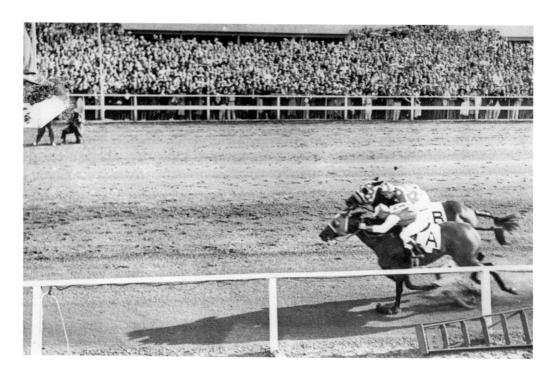

IN THEIR 1938 MATCH RACE, South American import Ligaroti, owned by Bing Crosby in partnership with Lin Howard, runs head-to-head with Seabiscuit, the reigning handicap champion of the West. Seabiscuit was owned by Lin's father, Charles S. Howard. The event is remembered as the one that put Del Mar permanently on the map. (Courtesy of Del Mar Thoroughbred Club.)

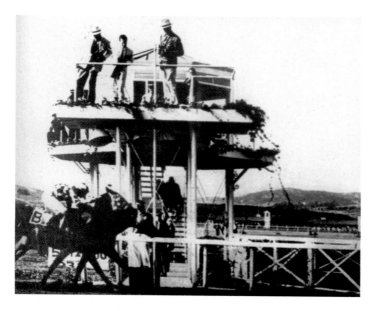

THE STEWARDS ARE ATOP the steward stand looking down on Seabiscuit and Ligaroti as they pass the finish line. From here, the stewards studied the controversial duel between the two horses from their vantage point directly over the action. Oscar Otis, who called the race, commented that he had never seen so much trouble in one race, which raised a stink about the result. (Courtesy of the Del Mar Thoroughbred Club.)

EARLY DEL MAR RACING

C. S. HOWARD, owner of Seabiscuit, accepts the winner's trophy from Dixie Crosby after the historic match race. Looking on are Mrs. C. S. Howard and Bing Crosby, at left, while at far right is Lin Howard. Bing Crosby appears to be envying the trophy so near his grasp, as he was only a horse's head away from winning it. (Courtesy of Del Mar Thoroughbred Club.)

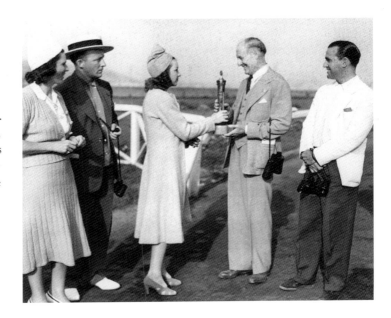

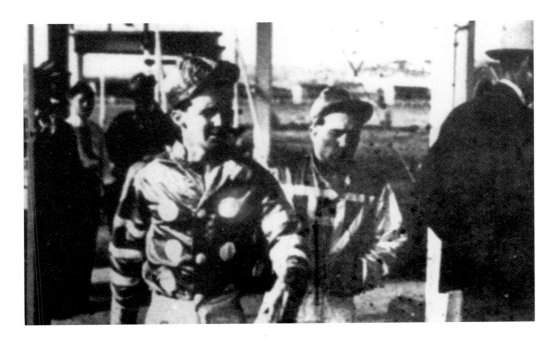

THE TWO JOCKEYS that rode in the popular match race between Seabiscuit and Ligaroti are walking away from their horses immediately after the very exciting race. Pictured here, from left to right, are rider Noel Richardson, who rode Ligaroti, and rider George Woolf, who rode Seabiscuit. Each jockey rode extremely hard to win this important race. (Courtesy of the Del Mar Thoroughbred Club.)

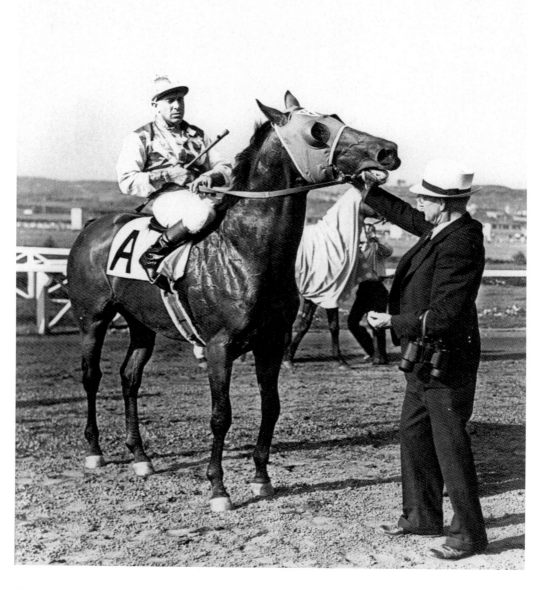

TRAINER TOM SMITH is pictured here greeting Seabiscuit and jockey George Woolf on the track at Del Mar following their win over Ligaroti. Seabiscuit won the race by a nose in 1 minute, 49 seconds, which broke the track record by four full seconds, but the result had to withstand an inquiry immediately posted by the stewards. Both horses fared well after this race. (Courtesy of Del Mar Thoroughbred Club.)

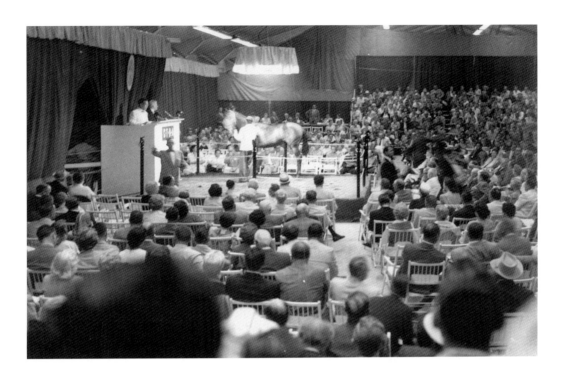

PICTURED HERE IN THE EARLY YEARS of racing was the auction pavilion, where sales were presented for years on the fairground property before moving down the road to the new Del Mar Horse Park. The annual Del Mar Yearling Sale has started many race goers on the road to horse ownership. (Courtesy of Del Mar Thoroughbred Club.)

PAT O'BRIEN AND BING CROSBY are pictured with their eyes obviously on a race. They often watched from this vintage point because it was high above the oval and had a good view of all points of the track. It was here that Bing probably sang, at the end of each race, the famous song, "Where the Turf Meets the Surf at Old Del Mar." (Courtesy of Del Mar Thoroughbred Club.)

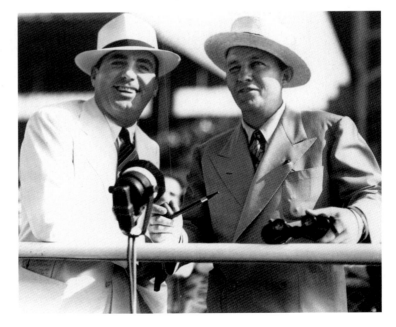

ACTRESS JUNE HAVER, at left, and dancer Ann Miller are pictured here at Del Mar ready to enjoy one of the day's early races. June showcased her acting talent in *Irish Eyes are Smiling.* Ann starred in over 40 motion pictures and Broadway shows, played Ginger Roger's dancing partner at age 14 and excelled in dancing throughout her career. (Courtesy of Del Mar Thoroughbred Club.)

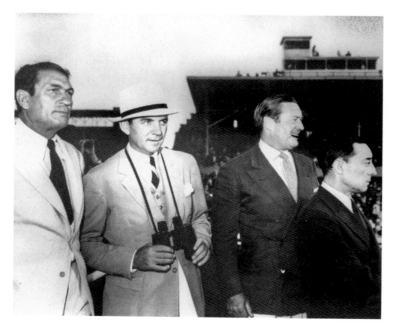

PICTURED HERE, from left to right, are actor Victor McLaglen, general manager William Quigley, actor Edmund Lowe, and deadpan comic Buster Keaton. All eyes appear to be turned toward the track, obviously in anticipation of the outcome of the current race. Note the NBC facility on the stadium roof where numerous broadcasts originated. (Courtesy of Del Mar Thoroughbred Club.)

EARLY DEL MAR RACING

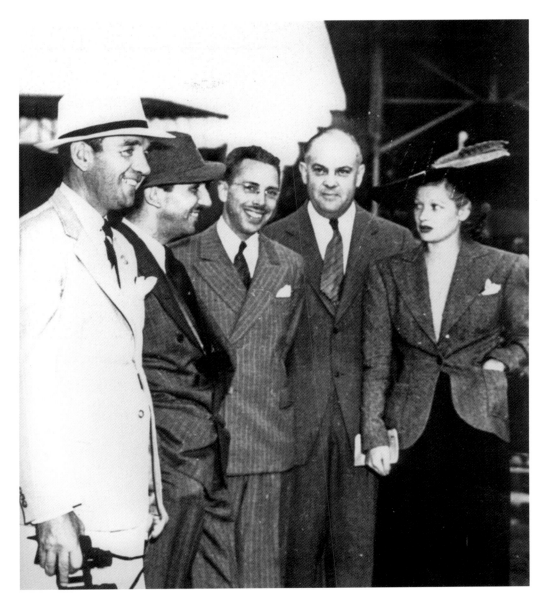

BILL QUIGLEY, pictured at far left, is entertaining a number of guests on a race day at Del Mar. To the immediate right is Walt Disney, and at far right is a youthful Lucille Ball. It was not unusual for Bill's busy day to include hosting groups of celebrities like this. They were always welcome because they attracted fans to the track. (Courtesy of Del Mar Thoroughbred Club.)

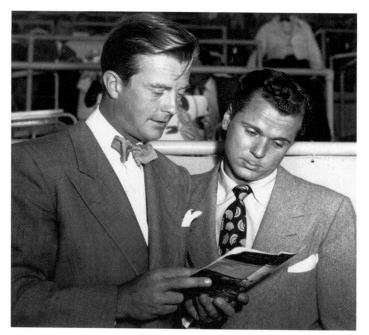

ACTORS WILLIAM LUNDIGAN (left) and Jackie Cooper have teamed up for a day at the races at Del Mar. William spent 13 years as an announcer before being discovered by a Universal film executive in 1937. Jackie was a child film star. His popularity ebbed when he reached adolescence, but he later moved to television and found success as not only an actor but also as a producer and director. (Courtesy of Del Mar Thoroughbred Club.)

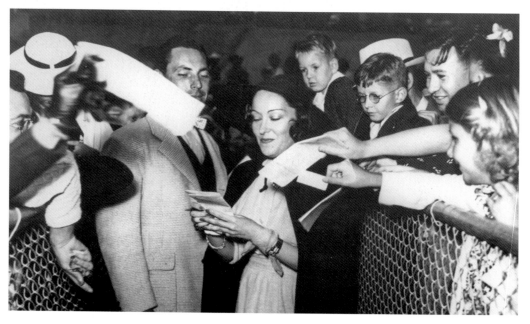

GLORIA SWANSON'S TIME AT THE TRACK was not totally taken up by watching the races. Here she is pictured signing autographs for an anxious crowd of fans, who extend available paper to her. Gloria was a silent-movie actress, a major box-office draw of that era. Her transition to the new medium of "talkies" was only moderately successful. She retired in 1934. (Courtesy of Del Mar Thoroughbred Club.)

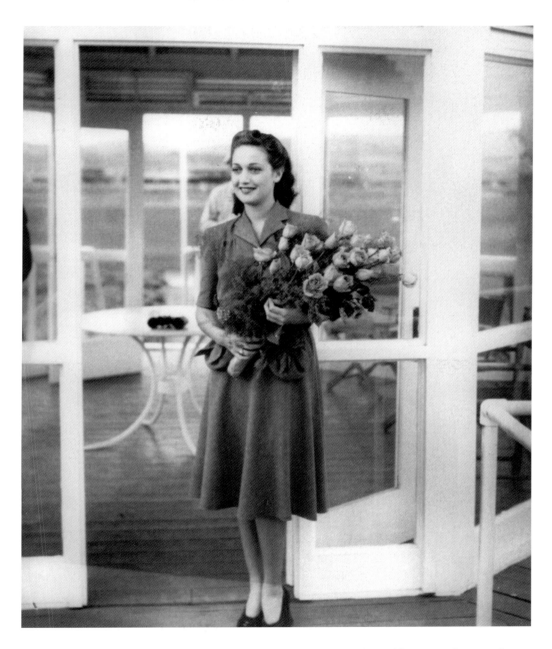

PICTURED HERE IS DOROTHY LAMOUR without her sarong. Instead she is decked out in an attractive dress and holding an armful of beautiful roses, made ready for the winner of an approaching race during the summer of 1940. Celebrities of this caliber were always welcome at Del Mar and always added much to the fan's enjoyment while viewing the winner's circle. (Courtesy of Del Mar Thoroughbred Club.)

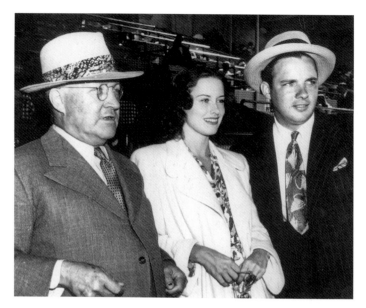

IN THE EARLY YEARS, the race crowd at Del Mar was often never complete without some members of Bing's family present. Pictured here are Bing's father, Harry L. Crosby Sr. (left); his brother Bob; and Bob's wife, June. The family always enjoyed getting together at the track, and sometimes it was a gathering place for friends that had not been together for a while. (Courtesy of Del Mar Thoroughbred Club.)

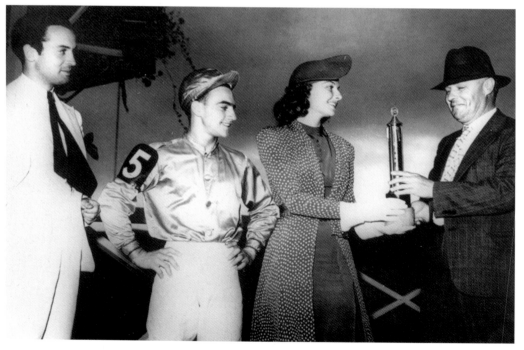

ANN SHERIDAN PRESENTS the trophy to trainer Bill Finnegan after the 1938 La Jolla Handicap, won by Dogaway with jockey Eddie Yager (next to Ann). Also participating in the ceremony was actor Eddie Norris at the extreme left in the photograph. Ann matured into a leading star who could adapt to any role. She was favorite pinup, along with Betty Grable. (Courtesy of Del Mar Thoroughbred Club.)

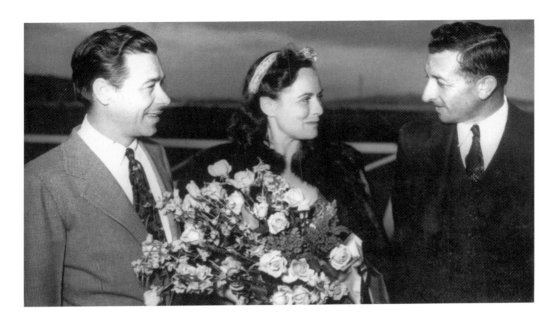

APPEARING IN THE WINNER'S CIRCLE during the 1938 opening season were Paulette Goddard (center), flanked by E. E. "Buddy" Fogelson (left) and friend W. R. Kanatzer. Col. Buddy Fogelson was a Dallas oilman, rancher, and lawyer who was married to Greer Garson, an award-winning actress. Paulette Goddard debuted with Ziegfield Follies at age 13 and went from there to superstardom. (Courtesy of Del Mar Thoroughbred Club.)

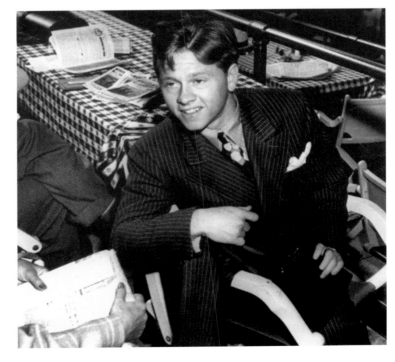

MICKEY ROONEY WAS AN ARDENT FAN at the Del Mar Racetrack, so much so that he piloted his own plane to Del Mar almost daily during the summer of 1940. He is pictured here adorned in a pin-stripped suit, a popular garb of that era. He came up through his career in child acting, and at this juncture was a singer, dancer, comedian, and talented young man. (Courtesy of Del Mar Thoroughbred Club.)

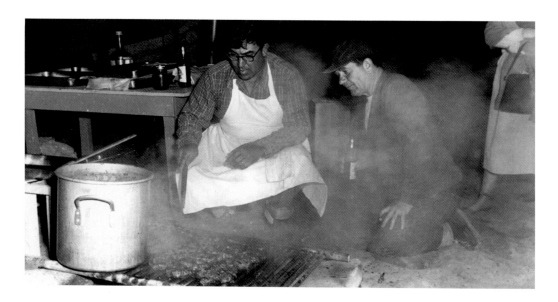

Since opening in 1937, Del Mar has been fortunate to have had three of the greatest announcers and callers in the history of Thoroughbred racing. The first was Joe Hernandez, seen in an apron at his annual fish fry at the beach. The second was Harry Henson, and the current voice is Trevor Denman. (Courtesy of Del Mar Thoroughbred Club.)

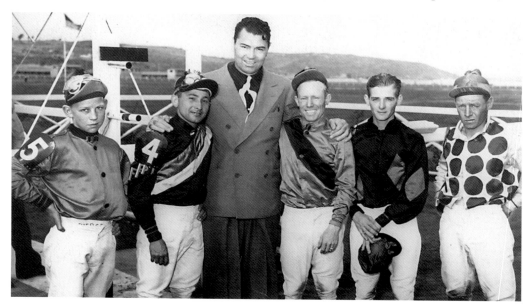

In 1937, former heavyweight champion Jack Dempsey visited the Del Mar track and posed with several jockeys. The group, from left to right, includes C. Pierce, Armando Fermin, Jack Dempsey, George Burns, Owen Webster, and Bobby Varner. Dempsey was popular with both fans and jockeys. (Courtesy of Del Mar Thoroughbred Club.)

POSTWAR RACING AT DEL MAR

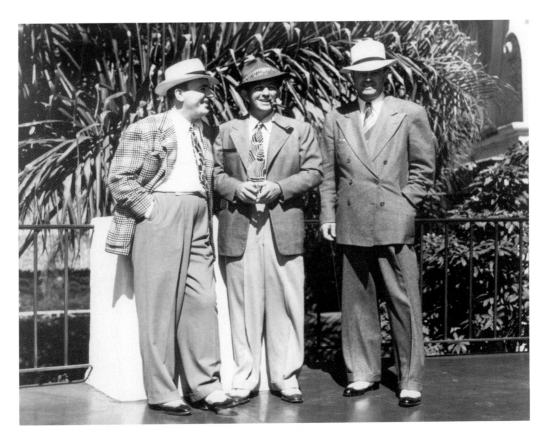

PICTURED HERE, from left to right, are Pat O'Brien, Bing Crosby, and the track's second general manager, Willard F. (Bill) Tunney, who was responsible for bringing the track back to life at the end of World War II. Racing ended on December 7, 1941, with the start of the war and did not begin again until July 11, 1945. During this time, it served as a Marine training course and manufacturing facility for wing ribs for Douglas B-17 bombers. (Courtesy of Del Mar Thoroughbred Club.)

Racetrack saw many Rosies who drove rivets

By Diane Welch

DEL MAR — During World War II, the community was transformed from a playground for celebrities o a town committed to aiding the war effort.

Many people signed up for active luty, and those left behind were active on the home front, according o an account in "Del Mar Looking Back," a book by Nancy Hanks Ewing, published in 1988 by the Del Mar History Foundation.

"The townspeople were very dedicated to the cause," local resident Margaret Dixon said in her interview for the book.

By December 1943, two years after the bombing of Pearl Harbor, a temporary assembly plant had been established at the racetrack and was in full operation.

"The Del Mar Turf Club made available 500,000 square feet of space at the fairgrounds under the grandstand and clubhouse and in he exhibit buildings, for aircraft subcontracting," Ewing wrote. Thus the Del Mar Turf Club Aircraft Division, run by (Bing) Crosby and Pat) O'Brien ... was created."

The company had a social club, known as Bing's Bomber Builders.

Many local women were hired o work at the racetrack assembly plant. Marge Dunham and Mary Marquez, both in their 20s, had worked at the Del Mar Drug Store on Camino del Mar before donning heir bandannas and signing on to 'ivet tail subassemblies.

"The Del Mar Racetrack was used as a production facility for B-17 bomber tail ribs, which were hen shipped up to a Long Beach acility to be assembled," longtime Del Mar resident Don Terwilliger, 74, said in a recent interview.

The Long Beach facility belonged to the Douglas Aircraft Co., which became one of the nation's biggest defense contractors during World War II. During peak war production, the company made 3,000 B-17 Flying Fortress bombers under license from Boeing, according to a 1994 article in *Blueprints*, the Journal of the National Building Museum. With men leaving jobs to fight in the war, factories were desperate for workers. The U.S. Government began a campaign to recruit women to build ships,

Marge Dunham (left) and Mary Marquez, who worked at the Del Mar assembly plant during World War II making tail subassemblies for B-17 Flying Fortresses, posed near the racetrack for this 1943 photo. *Courtesy of the Del Mar Historical Society*

planes and weapons and undertake other typically male professions.

An aircraft worker from New York, Rosalind P. Walter, was the inspiration for a song written by Redd Evans and John Jacob Loeb in 1942. They coined the moniker "Rosie the Riveter," according to a 1997 article in *The New York Times*. The song included lyrics such as:

While other girls attend their favorite cocktail bar,
Sipping dry martinis, munching caviar,
There's a girl who's really putting them to shame.
Rosie is her name. ...
She's making history working for victory,
Rosie the Riveter.

Sheridan Harvey wrote about the evolution of Rosie in an article on the Library of Congress' Web site in its Journeys and Crossings pages. A government commissioned poster, designed by J. Howard Miller in 1942, depicted a woman in overalls with flexed arm muscle and hair secured in a polka-dot bandanna.

A later illustration of Rosie by Norman Rockwell appeared on the cover of a 1943 *Saturday Evening Post*, making Rosie the Riveter a national phenomenon, Harvey wrote.

After the war, the number of working women never again fell to pre-war levels, Harvey added.

In 1944, the racetrack assembly plant was phased out, and Marquez and Dunham returned to their jobs at the Del Mar Drug Store.

By the summer of 1945, horse racing had resumed. The stands were full on Aug. 14, 1945, wrote Ewing, when O'Brien made a formal address to the hushed crowd that the war was over.

Diane Welch is a freelance writer from Solana Beach.

DIANE WELCH, a freelance writer from Solana Beach, wrote this story for the *San Diego Union-Tribune's* North County paper on Sunday, December 11, 2005. The story is apropos for inclusion here because it describes activities during the race suspension of the World War II years. (Courtesy of Diane Welch.)

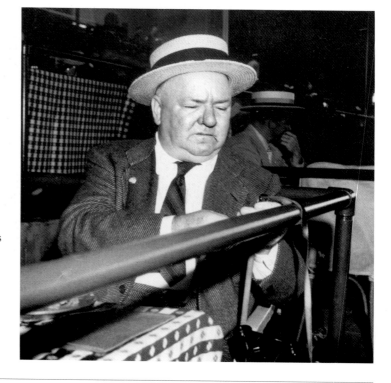

W. C. FIELDS, a great admirer of Del Mar, ponders the day's card at the track. He became an entertainer when he was discovered in an amusement park in Norristown, Philadelphia, performing as a skilled juggler. One of his most famous quotes is, "Never work with animals or children." However he secretly admired kids and obviously loved horses. (Courtesy of Del Mar Thoroughbred Club.)

THIS 1943 PHOTOGRAPH was taken at the Del Mar Racetrack during World War II when, due to the male labor shortage because of the war, women were hired to fill the gap. Marge Dunham (left) and Mary Marquez worked at an assembly plant making tail subassemblies for B-17 Flying Fortresses. (Courtesy of the Del Mar Historical Society.)

PICTURED HERE IS THE INTREPID George Raft escorting famed gossip columnist Louella Parsons. She was often at Del Mar, interviewing celebrities that came to the track. At this time, she was one of two of the most powerful gossip columnists in history. Her column in the Hearst papers was a force to be reckoned with. Parsons died on December 9, 1972. (Courtesy of Del Mar Thoroughbred Club.)

DURING THE YEARS that followed the end of World War II, the seaside track's involvement with celebrities increased. Big Nose, named after Harry's famous trumpet and winner of the 1951 Del Mar Futurity, is being given a snack by well-known bandleader Harry James. The colt was the first stakes winner sired in America by Khaled. (Courtesy of Del Mar Thoroughbred Club.)

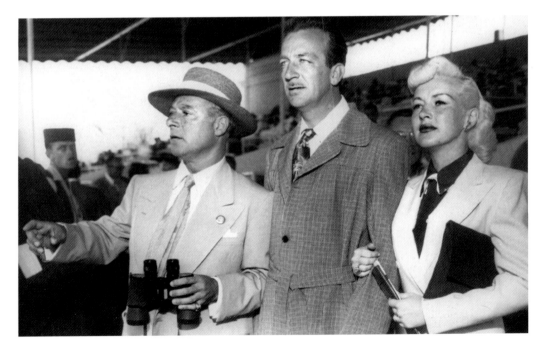

THE 1950S WERE INTERESTING YEARS at the track for Harry James and wife Betty Grable, pictured here with America's toastmaster, Gen. George Jessel. The James's owned a sizable racing stable and a 70-acre breeding farm, Baby J. Ranch, named after their daughter Jessica. Bandleader Harry was often on the road, but Betty was always at the barns in the morning, lending moral support to her horse in the saddling stable and presenting trophies in the winner's circle. (Courtesy of Del Mar Thoroughbred Club.)

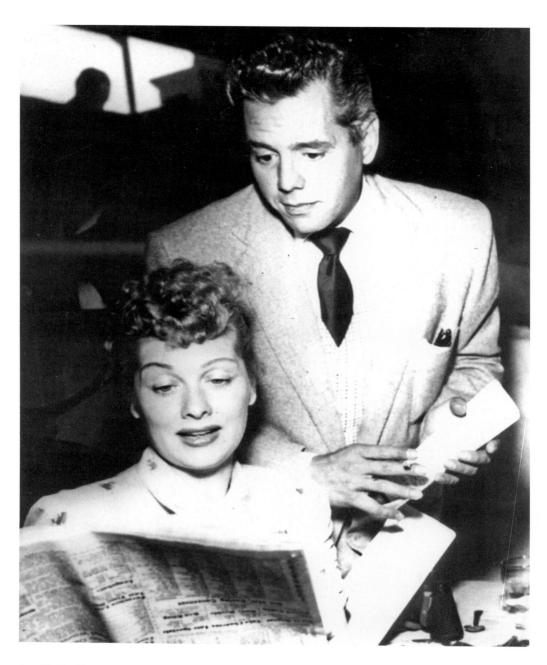

IN 1946, DESI ARNAZ AND LUCILLE BALL, America's funniest and most famous couple in the early years of television, had become regulars at the track. They were a popular twosome who raced their own horses at the oval. They also took up residence in Del Mar. After their divorce, Desi bought a home in Del Mar and became a local resident. (Courtesy of Del Mar Thoroughbred Club.)

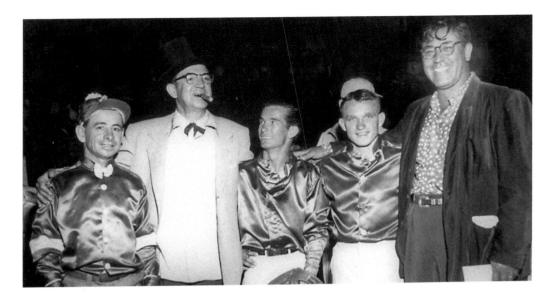

IT WAS NOT JUST ALL RIDING for the jockeys at the track, and sometimes the riders would engage in a softball game. One particular game drew comedian Joe Frisco and Joe Hernandez to the scene. The group pictured here, from left to right, are John Longden, Joe Frisco, Bill Shoemaker, Gordon Glisson, and Joe Hernandez. (Courtesy of Del Mar Thoroughbred Club.)

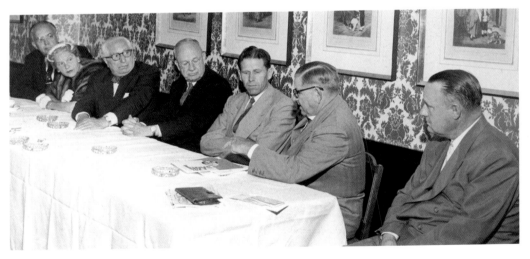

BY APRIL 17, 1946, it was announced that Bing Crosby had sold his stock in the Del Mar Racetrack. However the showbiz aura imparted by Crosby and his friends lingered, even though it had several new owners up through 1954. The 1954 board of directors, pictured here from left to right, are Walter Marty, Ann Peppers, L. B. Mayer, Gen. Holland Smith, Rex Ellsworth, Clint Murchison, and attorney C. Ray Robinson. (Courtesy of Del Mar Thoroughbred Club.)

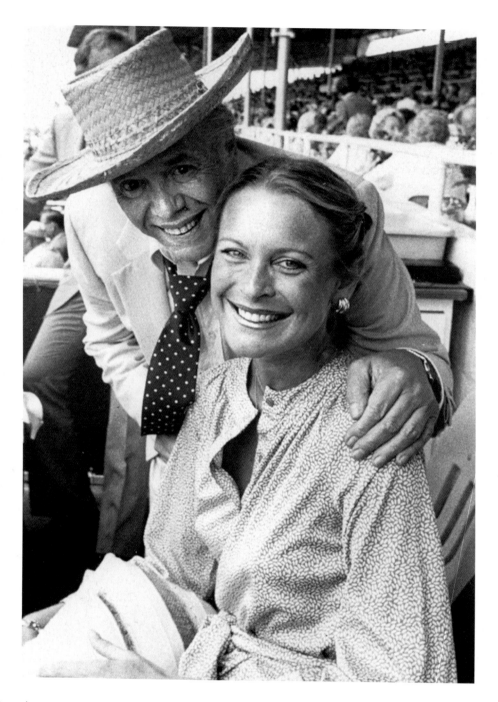

DESI ARNAZ STANDS BESIDE Bill Shoemaker's wife, Cindy. It was not only the Hollywood celebrities who attracted the race fans' attention but also the jockeys and many of their wives. William Shoemaker's beautiful wife was no exception. Her pleasant expression seems to indicate that she has been accepted into the celebrity club. (Courtesy of the author.)

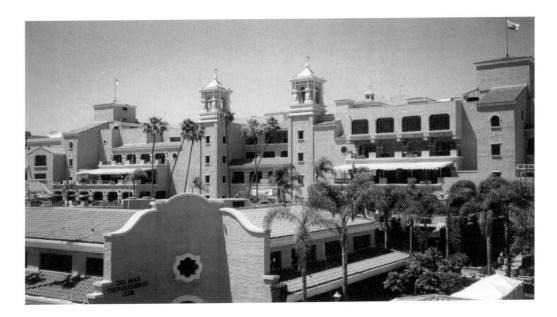

THIS PHOTOGRAPH provides a good view of the back of the stadium, showing the twin cupolas that were so cleverly designed into the architecture of the Spanish-style stadium. The foreground shows the Del Mar Thoroughbred Club's headquarters. The scene was photographed from a seat high on the Sky Ride during the 2004 San Diego County Fair. (Courtesy of the author.)

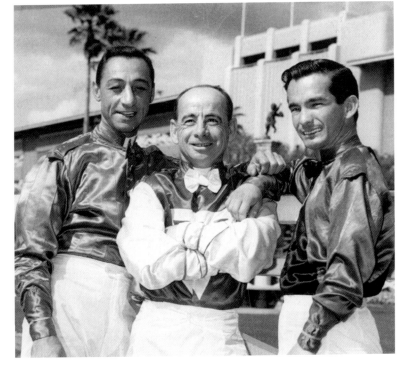

PICTURED HERE, from left to right, are three jockey greats: Eddy Arcaro, John Longden, and Bill Shoemaker. Each brought excitement to the racing world. Longden, the world champion who overtook Sir Gordon Richards of England, later relinquished the title to Bill Shoemaker. (Courtesy of Mr. and Mrs. Chase McCoy.)

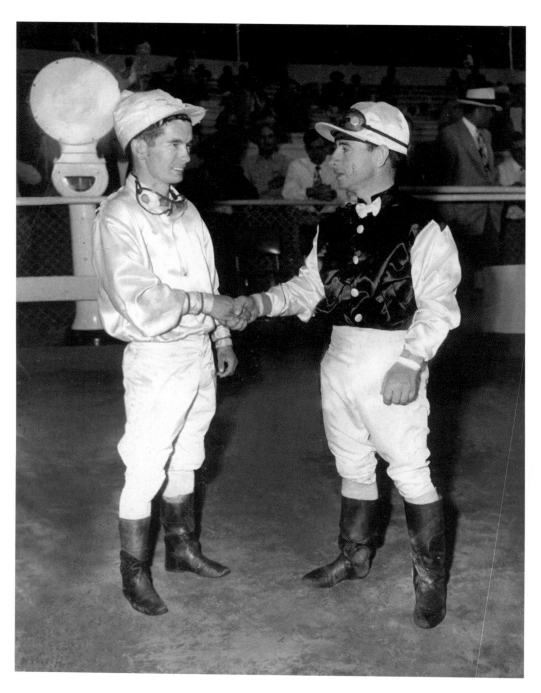

In 1949, young jockey sensation Bill Shoemaker, with his maiden victory barely behind him, won 52 races, a new track record at Del Mar. He is seen at left in 1950, shaking hands with John Longden, the brilliant veteran, after deadlocking with him for the Del Mar riding title with 60 victories. (Courtesy of Del Mar Thoroughbred Club.)

PICTURED HERE ARE Betty and John Mabee, both consignors and purchasers at the Del Mar Yearling Sale. They bought their first racehorses at the auction in 1957, established the Golden Eagle Farm in Ramona, won three Eclipse Awards, and became one of America's leading breeders. John died in April 2002, and Betty continues to serve on the Del Mar Thoroughbred Club Board of Directors. (Courtesy of Del Mar Thoroughbred Club.)

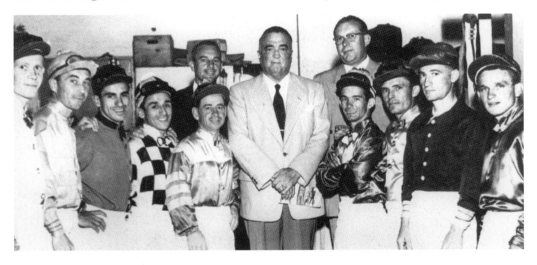

PICTURED HERE IS FBI BOSS J. Edgar Hoover (center), a summer regular, on a visit to the jockey's room in 1959. He used his yearly checkup at Scripps as an excuse for whiling away the afternoons in the grandstand. The group, from left to right, are (first row) Donald Bowcutt, Billy Pearson, Henry Moreno, Pete Moreno, John Longden, J. Edgar Hoover, Bill Shoemaker, R. L. Baird, Euclid Le Blanc, and Gordon Glisson; and (second row) Bert Thompson of the Jockey's Guild and O. L. McKinney, the Del Mar general manager. (Courtesy of Del Mar Thoroughbred Club.)

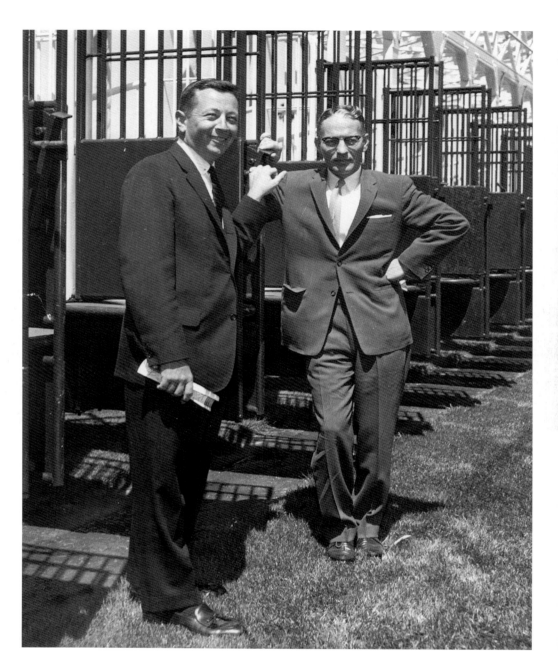

GIL STRATTON, OF CBS, stands next to Del Mar's remarkably accurate Harry Henson at the starting gate. Announcer Harry Henson replaced Joe Hernandez, taking over the microphone in 1967. He was Del Mar's announcer for a number of years. Gil Stratton was on hand for numerous races, keeping the public informed on racing events. (Courtesy of Del Mar Thoroughbred Club.)

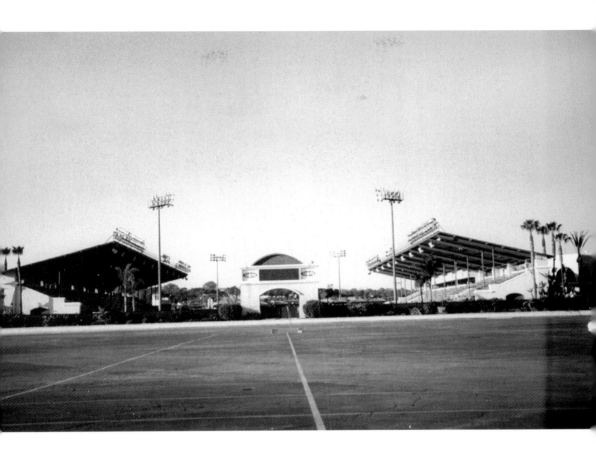

THIS PHOTOGRAPH SHOWS the entrance to a large arena near the track stadium. The grandstand covers have large banks of lights above so that activities can be performed at night as well as during the day. Although this is a facility that chiefly caters to activities during the fair season, it can also be used during the racing meet for special events. (Courtesy of the author.)

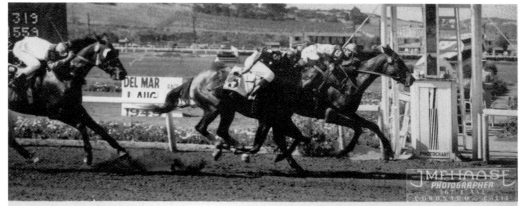

GALVANIZER J. LONGDEN UP.

WINNING THE "PUPPET SHOW PURSE" AUGUST 1, 1949 AT DEL MAR, CALIFORNIA.

Holiday Dream (2nd) (6 furlongs-1:12.3) Remuda (3rd)

J.R. WILLIAMS, Owner. D. SCHUNK, Trainer.

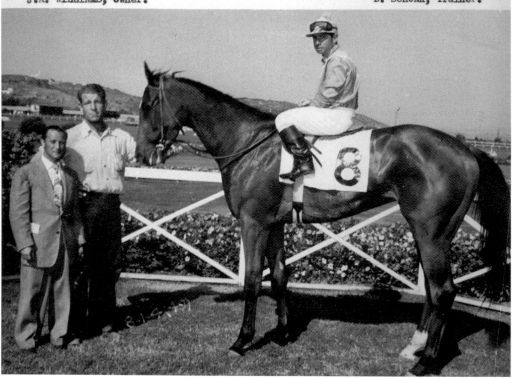

JOHN LONGDEN IS PICTURED HERE on Galvanizer, the winner of the Puppet Show Purse at Del Mar on August 1, 1949. The winner's circle shows the prized horse with the groom holding the reins and trainer D. Schunk standing beside him. The inset above shows the six-furlong race to be a close call. (Courtesy of Mr. and Mrs. Chase McCoy.)

MISSION TOWER IS THE FIFTH LARGEST of the five indoor exhibit halls. It measures 150 feet by 88 feet, with a ceiling height of only 18 feet. Although small, it can accommodate 1,200 people or 65 booths. It is very appealing to the fairgrounds because of its Mission-like architecture. It lures many visitors. (Courtesy of the author.)

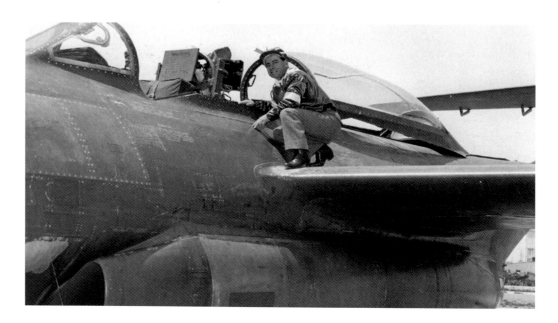

JOHN LONGDEN'S GOODWILL TRIP to Vietnam gave him an opportunity to view some of the planes used there during that time. He is pictured here on the wing of one that caught his interest. At home, John had his own plane and employed a pilot who flied him to special events and sporting adventures. (Courtesy of Mr. and Mrs. Chase McCoy.)

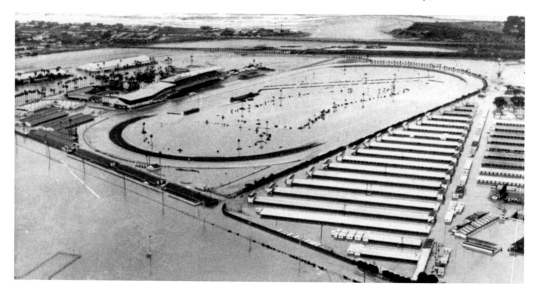

THIS VIEW OF THE OVAL Del Mar Racetrack and grounds was taken in 1980 looking southwest. It depicts a racecourse almost totally submerged in water. The racetrack and its surrounding buildings took a heavy pounding from the storms of 1980. Repairs were made, however, and racing continued that summer. (Courtesy of Del Mar Thoroughbred Club.)

JOHN MABEE, president of the Del Mar Thoroughbred Club, nurtured the dream of establishing a Grade 1 stakes race with a $1 million purse at Del Mar. His dream came true with the running of Del Mar's first million-dollar race in 1991—the Pacific Classic. It was won by Best Pal, pictured here, who went on to win 18 races, including four Grade 1 races. (Courtesy of Del Mar Thoroughbred Club.)

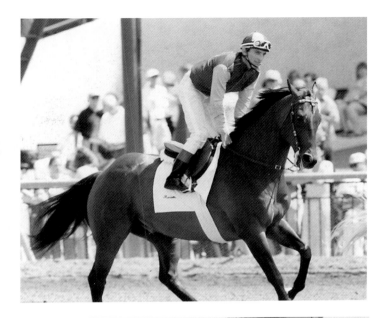

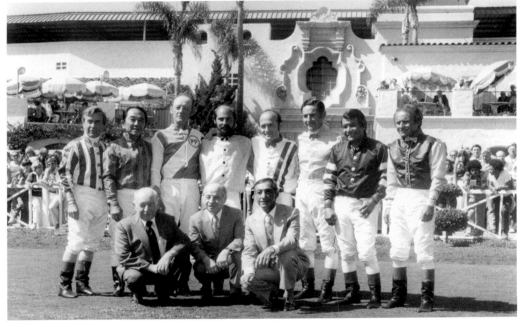

IN 1976, the Rocking Chair Derby became horse racing's answer to baseball's old-timer's game. The derby was cleverly dreamed up in 1973 by Dan Smith, today's director of media at the Del Mar Thoroughbred Club. Its participants, from left to right, are (first row) honorary stewards Johnny Adams, John Longden, and Eddie Arcaro; and (second row) Ken Church, George Taniguchi, Dave Gorman, Dean Hall, Bill Harmatz, Eric Guerin, Angel Valenzuela, and Ralph Neves. (Courtesy of Del Mar Thoroughbred Club.)

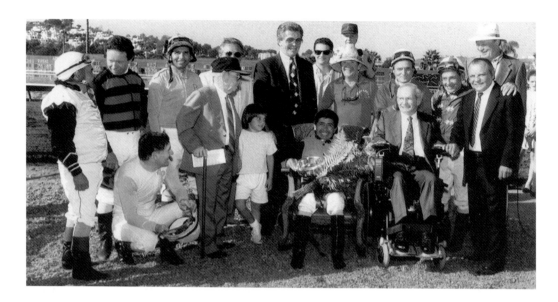

RETIRED JOCKEY DANNY VELASQUEZ is sitting in the rocking chair after winning the 1991 Rocking Chair Derby race. He is flanked by veteran jockey John Longden, on his right with cap and cane, and Bill Shoemaker, on his left in a wheelchair. Del Mar Thoroughbred president Joe Harper stands behind in a dark suit and tie. Danny sits here among other Rocking Chair Race participants. (Courtesy of Mr. and Mrs. Chase McCoy.)

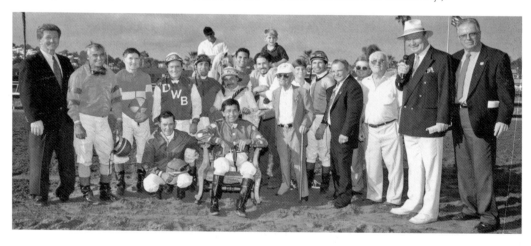

SEATED IN THE ROCKING CHAIR is Danny Velasquez, winner of the 1994 and 1997 derbies. Others in the postrace photograph, from left to right, include Del Mar president and general manager Joe Harper; race participants Alex Maese, Jack Leonard, Ray York, Bill Harmatz, Rudy Rosales, and Rudy Campas; honorary steward John Longden; Frank Olivares; steward Milo Valenzuela; former riders Tom Wolski and Gene Pederson, who was master of ceremonies; Ernie Myers; and Del Mar director of marketing and media Dan Smith, who came up with the idea for the Rocking Chair Derby. (Courtesy of Del Mar Thoroughbred Club.)

PICTURED AT RIGHT, BEING LED on the parade ground, is beautiful Star Fiddle with Hubert Trent aboard. White Star Stable's horse, Star Fiddle, won the first Del Mar Futurity in 1948. From 1958 to 1972, Star Fiddle came back to Del Mar every summer to lead the Futurity post parade. Hubert Trent was later a Rocking Chair Derby member and after Star Fiddle's demise in 1978, the track discontinued the derby. It was revived in 1994 with a new crop of "old timers" and continued until its finale in 1998. (Courtesy of Del Mar Thoroughbred Club.)

THE PLAN FOR building a new stadium had been in the works for years, and no sooner had the 1991 season ended than wrecking crews began dismantling the old grandstand. Pictured here are general manager Joe Harper (left) and director of operations Harry "Bud" Brubaker, who took ceremonial first swings as the first half of the old grandstand was razed in 1991. (Courtesy of Del Mar Thoroughbred Club.)

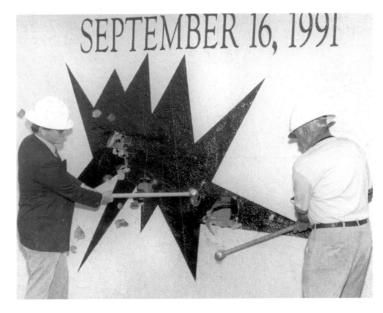

SEPTEMBER 16, 1991

HOAGY CARMICHAEL was a great composer, jazz musician, songwriter, and singer. He wrote song greats such as "Georgia on My Mind," "Up a Lazy River," and "Star Dust," which has been called the most recorded song ever written. He is pictured here contemplating a winner for the next race at Del Mar. He entertained at numerous Del Mar parties. (Courtesy of Del Mar Thoroughbred Club.)

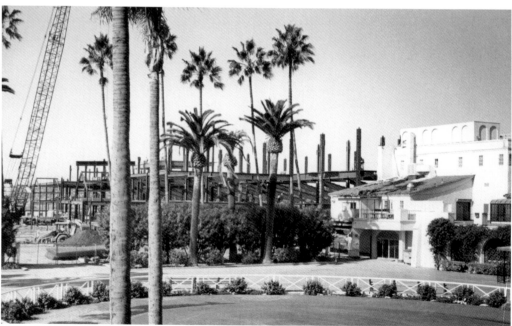

GRANDSTAND RECONSTRUCTION AT DEL MAR was in progress from 1991 to 1993. It began when the west half of the old Del Mar grandstand was torn down at the end of the 1991 meet. Pictured here is demolition of the west wing. This section was rebuilt during the off-season to make ready for the 1992 meet. (Courtesy of Del Mar Thoroughbred Club.)

POSTWAR RACING AT DEL MAR

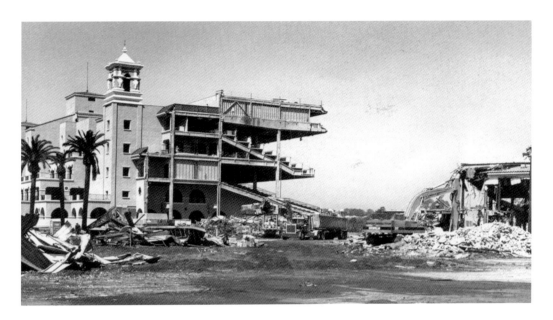

PICTURED HERE IS THE EAST SIDE of the old Del Mar Stadium, seen after the west half had been demolished but not rebuilt. It was half finished by the opening of the 1992 summer meet, but fans could actually use the half-completed facility. Consequently the 1992 racing season was conducted with half of the old grandstand and half of the new one. (Courtesy of Del Mar Thoroughbred Club.)

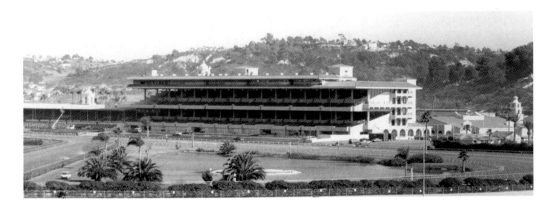

THE NEWLY CONSTRUCTED WEST HALF of the Del Mar Stadium and some of the rubble remaining from the demolition of the east side is pictured here. Once the 1992 meet concluded, the remaining half of the old building was demolished and eventually rebuilt, standing ready for the 1993 meet. (Courtesy of Del Mar Thoroughbred Club.)

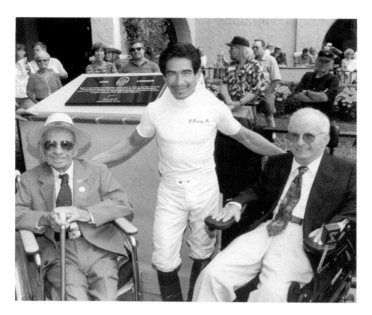

PICTURED HERE, from left to right, are retired jockeys John Longden, Laffit Pincay Jr., and Bill Shoemaker at the unveiling of plaques commemorating their championship achievements at Del Mar. Records for world-champion jockey riding were accomplished by Longden in 1956 and Shoemaker in 1970. Before retiring in 2003, Pincay beat Shoemaker's record late in 1999 with 9,530 total winners. (Courtesy of Del Mar Thoroughbred Club.)

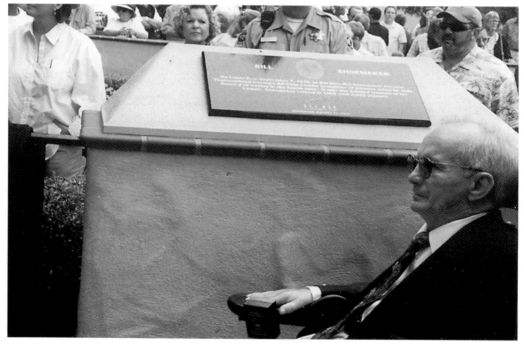

BILL SHOEMAKER IS SITTING beside a plaque in his honor. It was presented by the Del Mar Thoroughbred Club. The plaque reads, "On Labor Day, September 7, 1970 at Del Mar, Bill Shoemaker became Thoroughbred Racing's All-Time Leader in number of winners when he rode Dares J to victory in the fourth race. It was triumph 6,033 of his career." Shoemaker retired in 1990 with 8,833 winners. (Courtesy of Mr. and Mrs. Chase McCoy.)

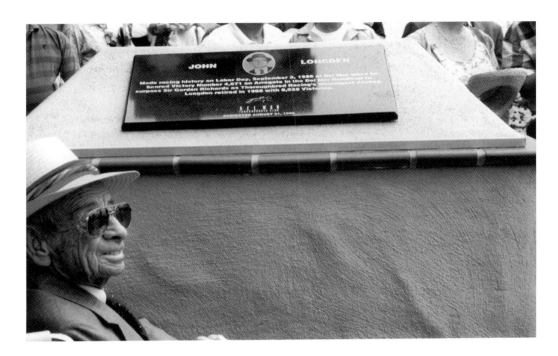

JOHN LONGDEN IS SITTING beside the plaque that commemorates his achievements at Del Mar. It reads, "John Longden made racing history on Labor Day, September 3, 1956 at Del Mar when he scored victory number 4,871 on Arrogate in the Del Mar Handicap to surpass Sir Gordon Richards as the Thoroughbred Racing's highest winning jockey." Longden retired in 1966 with 6,032 victories. (Courtesy of Mr. and Mrs. Chase McCoy.)

ANNOUNCER TREVOR DENMAN, a native of South Africa, is surrounded by members of his devoted fan club. Denman succeeded Harry Henson in 1984 and announced both for Del Mar and Santa Anita. Consequently the superb announcing continues at Del Mar. (Courtesy of Del Mar Thoroughbred Club.)

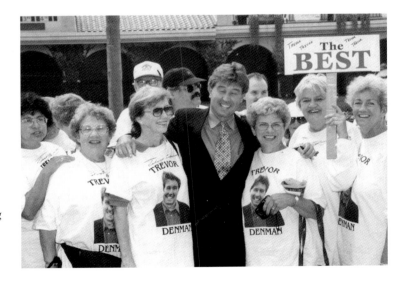

ON AUGUST 10, 1995, Russell Caputo ran out on the track during the eighth race at Del Mar in front of horses on the home stretch. Chris McCarron, aboard race favorite Sea of Serenity, was able to avoid him, as were the other riders. David Smith, of Del Mar Photography, captured this most bizarre incident in Del Mar history on film, which appeared nationally and internationally. (Courtesy of Del Mar Thoroughbred Club.)

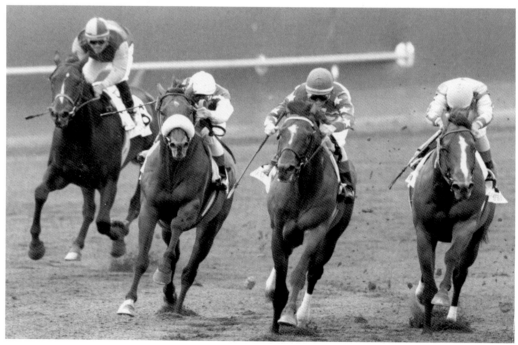

DARE AND GO, second from left, is rolling past Cigar, third from left, as they turn into the stretch at the 1996 Pacific Classic at Del Mar, ending Cigar's winning streak. If Cigar had held up this day, Citation's mark of 16 consecutive wins would have been broken. Few people imagined that the champion Cigar could be upset, especially since there appeared to be a relatively modest field of opponents. (Courtesy of Del Mar Thoroughbred Club.)

POSTWAR RACING AT DEL MAR

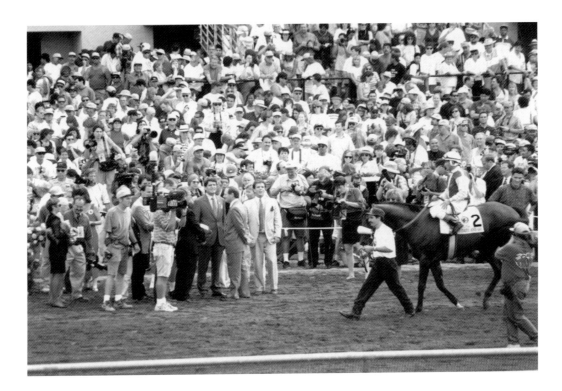

IN THIS PHOTOGRAPH, Dare and Go is being led into the winner's circle before the largest crowd in Del Mar history—44,181. Alex Solis is aboard the horse after the astounding upset of mighty Cigar in the 1996 Pacific Classic. If Cigar had won this race, Citation's record mark of 16 wins would have been broken. (Courtesy of Del Mar Thoroughbred Club.)

BRILLIANT AZERI IS EN ROUTE to "Horse of the Year" laurels in 2002, when she won the Clement L. Hirsh Handicap under Mike Smith. Trained by Laura de Seroux at San Rey Downs in nearby Bonsall, Azeri, racing in the colors of her breeder, the late Allen Paulson, won eight of nine starts to clinch her Eclipse Award. De Seroux became the first woman in Thoroughbred racing history to condition a "Horse of the Year." (Courtesy of Del Mar Thoroughbred Club.)

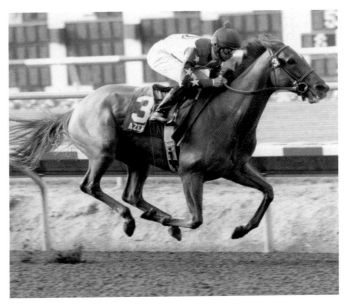

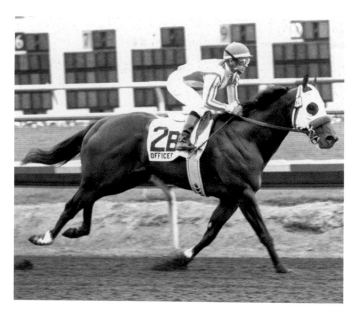

PICTURED HERE IS OFFICER, one of the most brilliant two-year-olds of recent years, winner of the 2001 Del Mar Futurity and son of Bertrando, a Futurity winner in 1991. He was originally bought for $175,000 and later resold to the Thoroughbred Corporation of Prince Ahmed bin Salman for $700,000. He won six of nine lifetime starts, including five stakes races. (Courtesy of Del Mar Thoroughbred Club.)

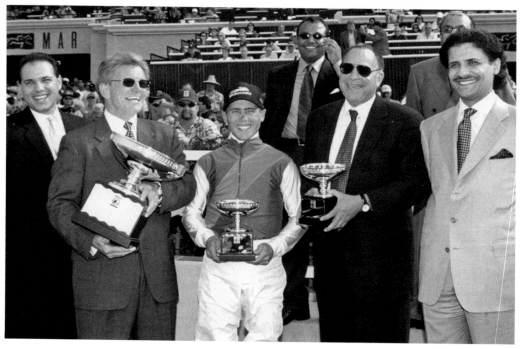

PICTURED WITH THEIR TROPHIES, from left to right, are Joe Harper, jockey Garrett Gomez, and Bobby Frankel after Juddmonte Farm's Skimming won the 2000 Pacific Classic, defeating eventual "Horse of the Year", Tiznow. Skimming repeated in 2001, again under Gomez, giving Frankel an incredible sixth success in 11 runnings of the Pacific Classic and Juddmonte Farms its fourth win in the million-dollar event. (Courtesy of Del Mar Thoroughbred Club.)

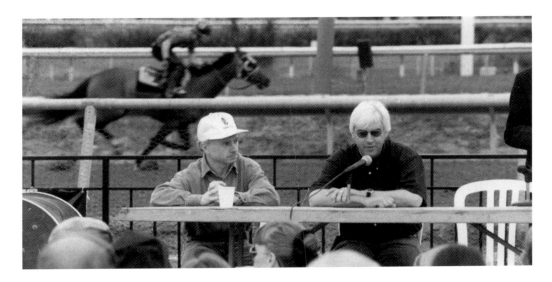

THE NOW-RETIRED JOCKEY Chris McCarron is pictured at left with Bob Baffert as Baffert rekindles memories of Red McDaniel and Farrell Jones during his domination of the Del Mar training ranks beginning in the late 1990s. In addition to six consecutive training championships at Del Mar, Baffert saddled the winners of the Del Mar Futurity an unprecedented seven straight years, from 1996 to 2002. (Courtesy of Del Mar Thoroughbred Club.)

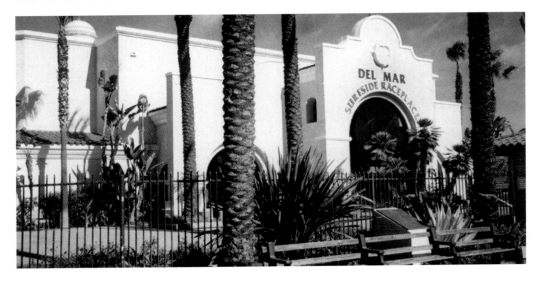

THIS IS THE ENTRANCE to the Del Mar Surfside Race Place, an almost 15-year-old off-track betting facility on the fairgrounds. It is open during the Del Mar racing season and provides access to major tracks both east and west. When fans go to the window at a satellite location like this to place a wager, it is just like being at the window at the track where the racing is being presented. (Courtesy of the author.)

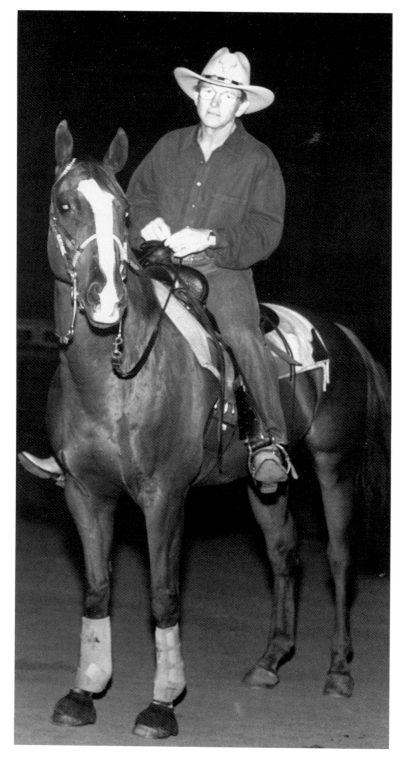

THE EARLY-MORNING HOURS around the Del Mar track are often misty and cool, but that does not hamper the activity that begins early in the summer racing season. A familiar, daily sight at the racetrack during morning training hours was Del Mar thoroughbred Club's president and general manager Joe "The Cowboy" Harper, pictured here on this beautiful horse. (Courtesy of Del Mar Thoroughbred Club.)

POSTWAR RACING AT DEL MAR

3

JOHN LONGDEN

DEL MAR'S WORLD CHAMPION

IN 1912, JOHN LONGDEN'S DAD, Herb, migrated from England to Taber, in Alberta, Canada, with the rest of the family to follow. The hand of fate played a role for young John Longden, for a delay in their train caused a missed passage on the *Titanic*. This photograph of John at age eight would not have been available and there would have been no world champion rider 41 years later if he had caught the ship. (Courtesy of Mr. and Mrs. Chase McCoy.)

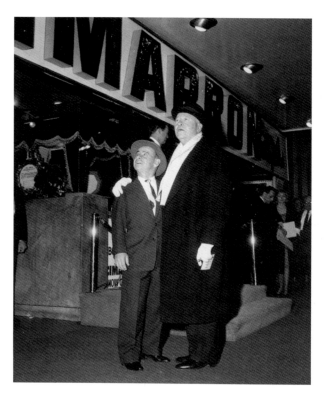

JOHN LONGDEN AND JACK OAKIE, who played in numerous movies from the 1920s through the 1960s, are pictured here together at the Cimarron Golf Resort in Palm Springs. The 36-hole facility was a favorite celebrity gathering place where they could come and relax, play golf, and meet one another. Golf was another sport that Longden enjoyed. (Courtesy of Mr. and Mrs. Chase McCoy.)

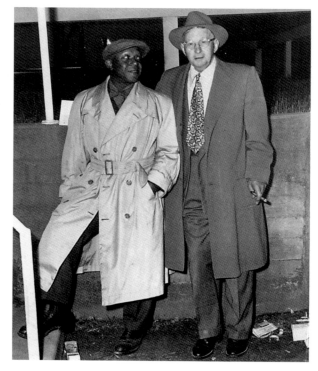

NUMEROUS FANS OF JOHN LONGDEN wished him well in his attempt to break the racing record. Eddie Anderson, the comic actor who became Jack Benny's chauffeur Rochester on the *Jack Benny Show*, and his friend Sleepy Armstrong, an ex-trainer, sent this photograph to John Longden with the greeting, "We were both pulling for you on your 4,000th, hope you make 8,000." (Courtesy of Mr. and Mrs. Chase McCoy.)

These well-known horse-racing men, from left to right, are John Longden, a star jockey at Del Mar; Chase McCoy; and Wally Dunne. McCoy was a horse owner who had many stakes winners. In 1961, his TV Lark won at the Los Angeles Handicap Race at Hollywood Park, ridden by jockey John Longden. TV Lark was voted Turf Horse of the Year in 1962. Dunne was a racehorse trainer. (Courtesy of Mr. and Mrs. Chase McCoy.)

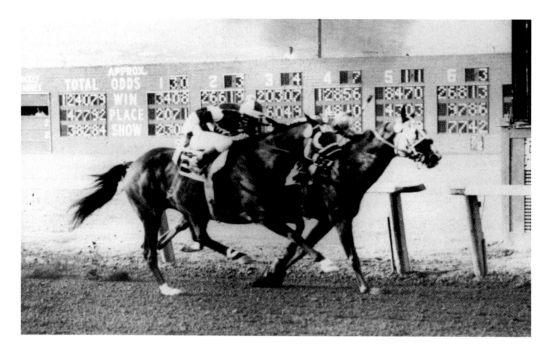

JOHN LONGDEN BECAME the world's top record holder for winning the most races in 1956, overtaking champion Sir Gordon Richards of England. Longden is pictured here on the rail with the winning horse, approaching the finish line in great shape. It was Labor Day at Del Mar, and this was his 4,871st record race, an important one. (Courtesy of Del Mar Thoroughbred Club.)

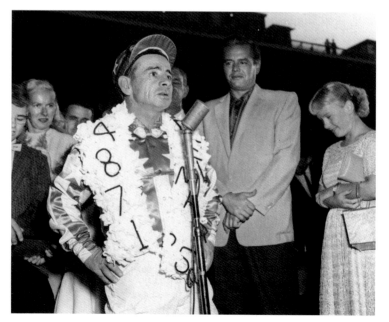

A CONFIDENT JOHN LONGDEN stands before the microphone, with hands on hips, telling the world how he was able to accomplish his record-breaking victory. However this was just the midpoint in his long and exciting career. Desi Arnaz is standing behind him, intently listening. (Courtesy of Del Mar Thoroughbred Club.)

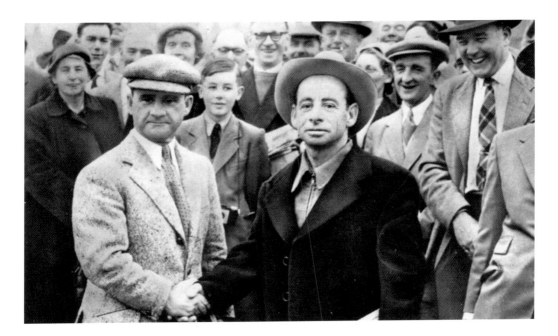

JOHN LONGDEN WAS ON VACATION in England with his wife, Hazel, three years before he took the world-champion title from Richards. Here he meets Sir Gordon Richards, at that time the world-champion rider and one of the best jockeys in England. They are pictured shaking hands, a meeting that would grow into a lasting friendship, bringing Richards to California and John back to England for other visits. (Courtesy of Mr. and Mrs. Chase McCoy.)

THE COMMON BOND of Thoroughbred racing was the inducement that cemented a great friendship between Sir Gordon Richards and John Longden. On one of John's trip to England, a loyal friendship was kindled between the two men. John and his wife were even greeted by Sir Winston Churchill. Pictured here are Sir Gordon Richards and John Longden, ready for a countryside tour. (Courtesy of Mr. and Mrs. Chase McCoy.)

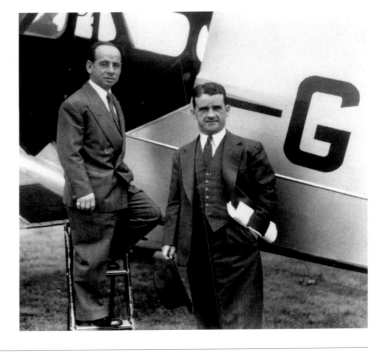

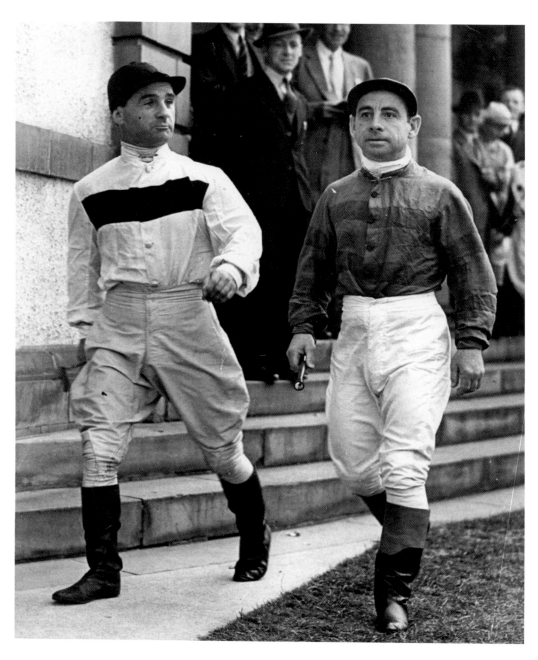

GORDON RICHARDS, England's world-champion jockey, and Johnny Longden leave the weighing station after they rode in their first race together at Doncaster, England, during Longden's tour there. Gordon won on Wat Tyler, the favorite. Johnny Longden rode Aga Khan's El Arabi and came in eighth. (Courtesy of Mr. and Mrs. Chase McCoy.)

THIS NEWS CLIP DESCRIBES the congratulations sent to John Longden from Sir Gordon Richards, the world-champion jockey who was from and in England at the time, after John surpassed his record. This was a heart-warming message to John, who had met Richard during a previous visit to England. They would become lifelong friends. (Courtesy of Mr. and Mrs. Chase McCoy.)

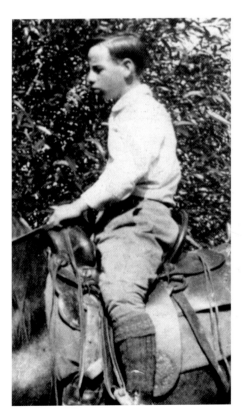

DURING HIS EARLY RIDING on the prairies around Taber, in Alberta, Canada, and cattle herding for a neighbor, young John Longden, pictured here, realized that he was at his best on a horse. He was not sure what his future held, but he was sure that it would involve horses. Although a boyhood dream at the time, it intensified as he grew older. (Courtesy of Mr. and Mrs. Chase McCoy.)

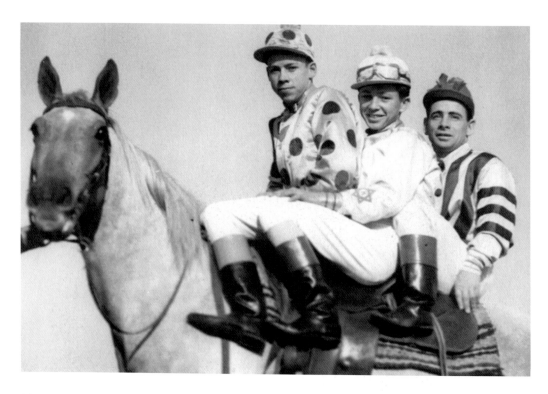

THREE YOUNG MEN jovially display that they all have their sights set on the future as jockeys. The three, from left to right, are B. James, F. Chojnacki, and J. Longden. Fortunately they picked a quiet and agreeable horse for their photograph shoot, even though it looks rather curious about the activity. (Courtesy of Mr. and Mrs. Chase McCoy.)

JOCKEYS OFTEN LIKED to get together and talk over past good and bad times. Pictured here, from left to right, are jockeys Alex Maise, John Sellers, John Longden, and Danny Velasquez, who by this point had retired and was training horses. It is evident that their gathering is a joyous one. (Courtesy of Mr. and Mrs. Chase McCoy.)

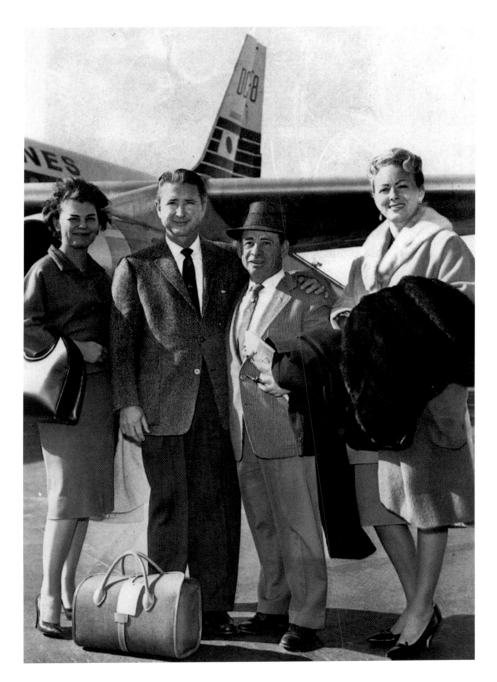

PICTURED HERE, FROM LEFT TO RIGHT, are Doris McCoy, Chase McCoy, John Longden, and Hazel Longden standing beside the DC-8 that flew them to Japan. Chase McCoy told the author that the trip was in celebration of his horse, TV Lark, and Longden previously winning a race. They also looked forward to visiting Hong Kong. (Courtesy of Mr. and Mrs. Chase McCoy.)

PICTURED HERE, FROM LEFT TO RIGHT, are Doris McCoy, her husband, Chase, Hazel Longden, and her husband, John, who have arrived safely in Japan. They are attending a 1962 function hosted by the Japanese Racing Association. The following day, they went to the races in Japan and saw country's top jockey, Watanabe, race. Later they visited Hong Kong. (Courtesy of Mr. and Mrs. Chase McCoy.)

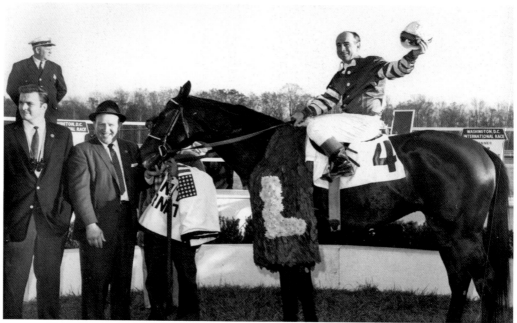

JOHN LONGDEN, aboard TV Lark, is in the winner's circle after a victory in the Laural International Race for horses around the world. He beat the great Kelso by three-fourths of a length and left the rest of the field by 15 lengths. TV Lark was owned and syndicated by Chase McCoy. Pictured in front of TV Lark is Paul K. Parker, who syndicated the horse before the race and Preston Madden, at his right, a Kentucky breeder. (Courtesy of Mr. and Mrs. Chase McCoy.)

THIS IS A PHOTOGRAPH taken of John Longden and Connie Hines, who starred in the *Mr. Ed* television series with Alan Young and Mr. Ed, the talking horse. The television show was a CBS situation comedy that ran from 1961 to 1966. In this photograph, it almost appears that John Longden is intently listening to Mr. Ed while Connie is admiring the star of her show. (Courtesy of Mr. and Mrs. Chase McCoy.)

THIS PHOTOGRAPH SHOWS John Longden aboard Mr. Ed with Connie firmly holding the jockey steady. Perhaps Mr. Ed whispered in John's ear that he would like to pose for a photograph with a famous jockey on his back. But of course, something like that could only happen on television. Alan Young revealed that Mr. Ed was given peanut butter to make him move his mouth and appear to be talking. (Courtesy of Mr. and Mrs. Chase McCoy.)

THROUGHOUT HIS CAREER as a jockey and trainer, John Longden met many celebrities, some of whom became good friends. Pictured here, from left to right, are John Longden; Roy Rogers; Chiomi, the wife of Longden's pilot; and Chase McCoy. John and Chase had been invited to visit Roy Rogers, and it was a delightful time for all. (Courtesy of Mr. and Mrs. Chase McCoy.)

THIS IS A SCENE IN Longden's home in Arcadia, California, where he lived with his wife, Hazel. It is full of trophies he earned during his truly magnificent career up to that time. Observe how his home contains both racing and hunting trophies. He appears to be viewing a painting of his mount Count Fleet, winner of the Kentucky Derby in 1943. (Courtesy of Mr. and Mrs. Chase McCoy.)

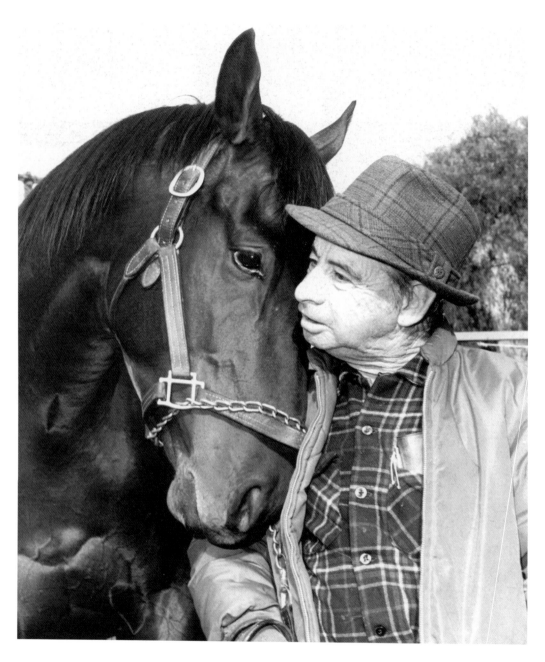

JOHN LONGDEN POSES with Money Lender, a beloved racehorse he liked to ride. Longden's admiration of Money Lender is apparent in this photograph and it seems to be reciprocated by the horse, which is perhaps not surprising considering the many relationships that existed between Longden and the horses he associated with during his long career as a jockey and trainer. (Courtesy of Mr. and Mrs. Chase McCoy.)

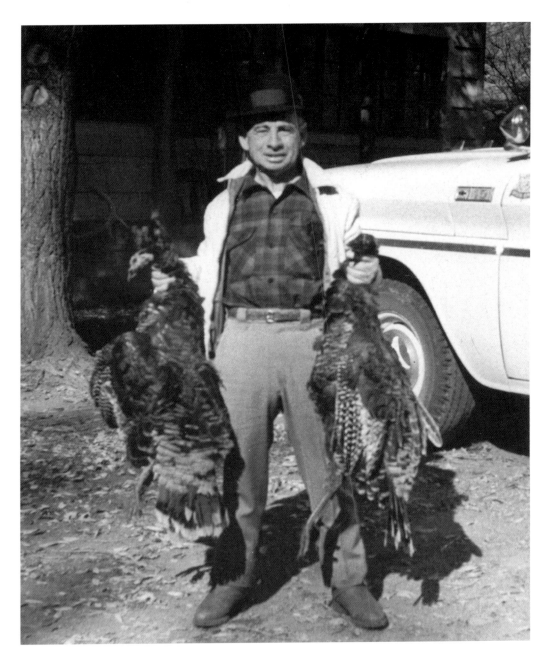

JOHN LONGDEN IS PICTURED HERE during a turkey-hunting expedition in Canada. When he wasn't racing Thoroughbreds, he was usually engaged in other forms of sport. He made numerous hunting trips to Canada with Northern California racing-track officials and his veterinarian friend, Dr. Cook. (Courtesy of Mr. and Mrs. Chase McCoy.)

DEL MAR RACETRACK

USO SHOWS

PRESENTS

AMERICA'S TURF AUTHORITY

Racing *Daily* Form

"ALL-TIME RACING GREATS"

WILLIE SHOEMAKER **BILL WINFREY** **JOHNNY LONGDEN**

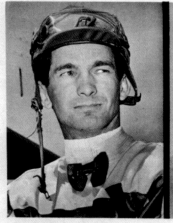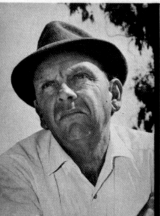

-TO VIETNAM

FOR DETAILS
CONTACT YOUR SPECIAL SERVICES OFFICER

WILLIAM WINFREY, pictured on the cover of this USO advertisement, was a Thoroughbred trainer in the national limelight for many years. His suggestion to the Hollywood Turf Club that he and jockeys John Longden and Bill Shoemaker volunteer for an overseas trip culminated in a Vietnam group tour for the three of them. Many celebrities joined the USO overseas circuit to visit and entertain servicemen in Vietnam. (Courtesy of Mr. and Mrs. Chase McCoy.)

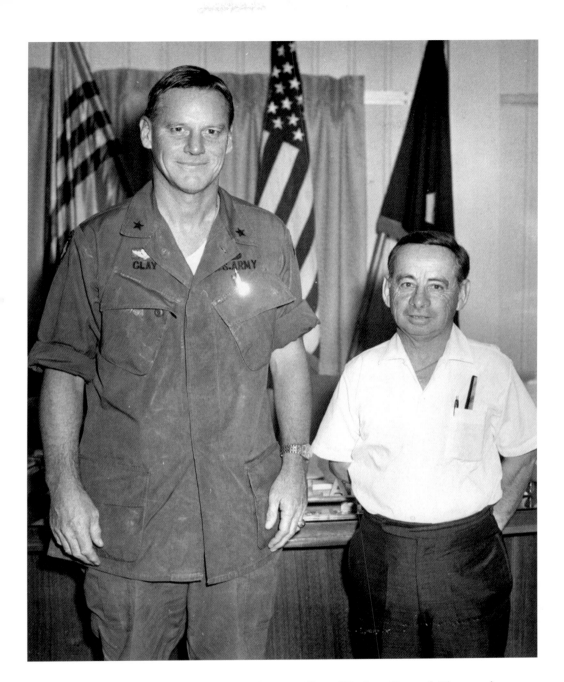

PICTURED HERE are Gen. Lucius D. Clay, commander of the 7th Air Force at Tan Son Nhut Airfield in the Republic of Vietnam, and John Longden, who had joined the USO overseas circuit with Bill Shoemaker and William Winfrey. General Clay was happy to have the threesome aboard to visit his troops, and he made them quite welcome during their tour in Vietnam. (Courtesy of Mr. and Mrs. Chase McCoy.)

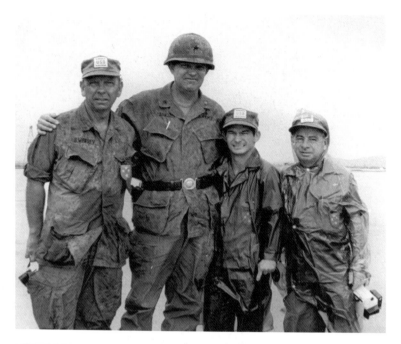

THIS PHOTOGRAPH WAS taken in Vietnam during a USO tour. Pictured here, from left to right, are Bill Winfrey, Gen. Lucius D. Clay, Bill Shoemaker, and John Longden. As General Clay's guests, the three were welcome visitors to the military base in Vietnam and thoroughly enjoyed mingling with and entertaining the military troops. (Courtesy of Mr. and Mrs. Chase McCoy.)

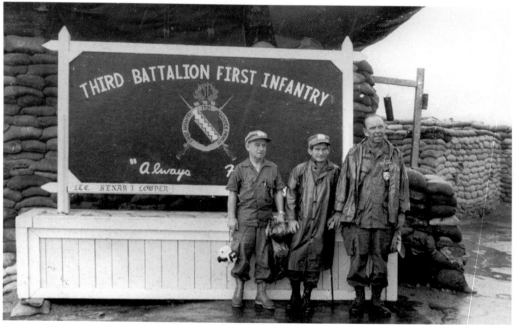

PICTURED HERE, standing from left to right in front of the 3rd Battalion 1st Infantry sign at their facility in Vietnam, are John Longden, Bill Shoemaker, and Bill Winfrey. Their USO tour had been quite a success, and it was quite an opportunity for them to visit the area. (Courtesy of Mr. and Mrs. Chase McCoy.)

HERE JOHN LONGDEN is standing beside a plane at the base in Vietnam where he, Bill Shoemaker, and William Winfrey were visiting on a USO tour. John's admiration of airplanes is quite evident as witnessed by this posed photograph with the popular plane used during the Vietnam War. (Courtesy of Mr. and Mrs. Chase McCoy.)

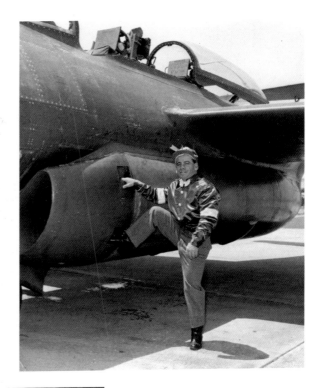

JOHN LONGDEN IS PICTURED HERE with one of the horses he was training at his Riverside Ranch sometime after he retired and began breeding and training Thoroughbreds. The muzzle on the horse was to keep it from eating before training. John sold his Riverside Ranch to Alberta Ranches and continued training and producing stock for them. (Courtesy of Mr. and Mrs. Chase McCoy.)

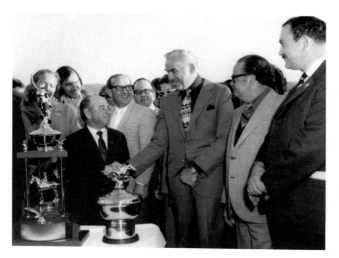

THIS IS THE TIJUANA RACETRACK in Tijuana, Baja California, during one of John Longden's visits. He is shaking hands with Lorne Greene, a star cast member of the 1960s television series, *Bonanza*, who is congratulating John on his honorary racing there. From left to right, behind large trophy, are Hazel Longden, Eric Longden, John Longden, Vance Longden, and Lorne Greene. (Courtesy of Mr. and Mrs. Chase McCoy.)

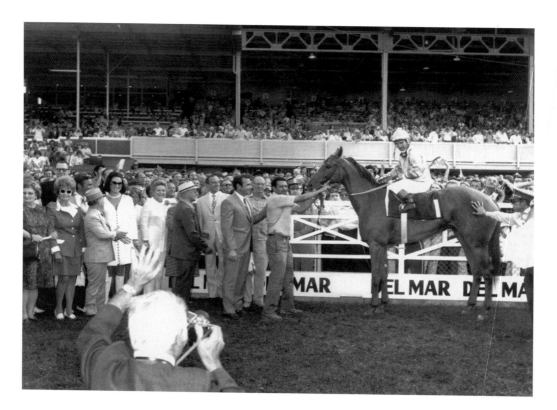

BILL SHOEMAKER, aboard Dares J, has arrived in the winner's circle after winning the race that clinched his record as leading jockey. John Longden, third from left, joins the group in the winner's circle in saluting Bill Shoemaker. Being the good sport that he was, he was eager to give Bill his congratulations. (Courtesy of Del Mar Thoroughbred Club.)

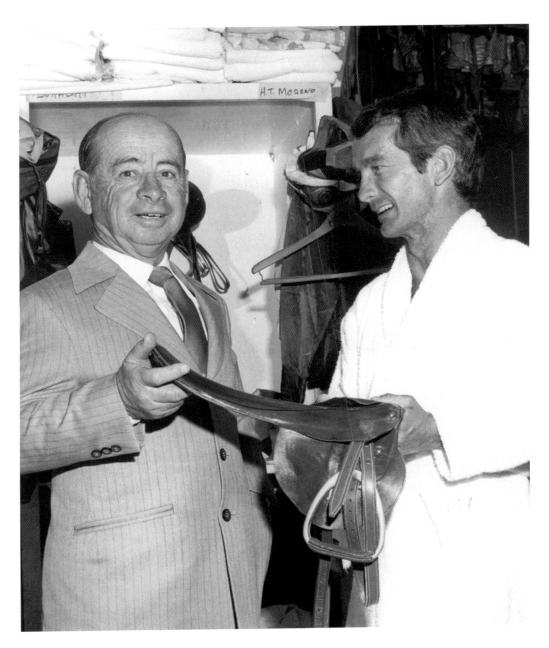

THIS IS A PHOTOGRAPH of John Longden and Bill Shoemaker in the jockey's room on Labor Day in 1970, the day that "Shoe" broke Longden's record. They were great friends, and it is obvious John Longden held no animosity toward losing the title. Longden seems happy to hand over the prized saddle to his younger cohort. (Courtesy of Del Mar Thoroughbred Club.)

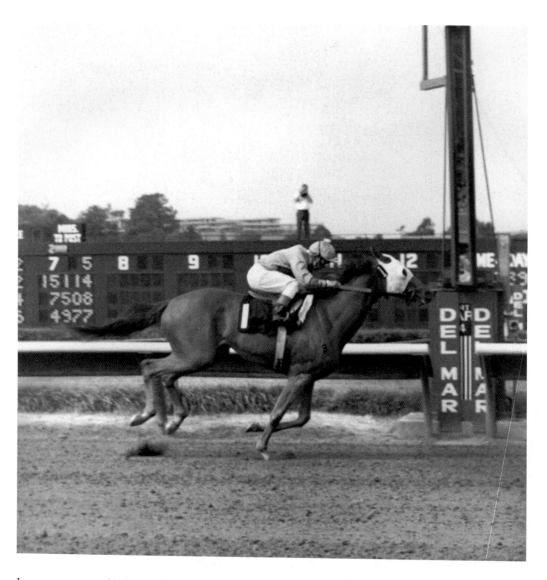

IT WAS EXACTLY 14 YEARS after John Longden capped the world record on Labor Day in 1956 that Bill Shoemaker's mount, Dares J, pictured here, flashed to victory and made the Texas native the leading rider of all time. It was his 6,033rd win, a record that brought his fans jubilation. He was destined to record 2,800 more wins before retiring in 1990. (Courtesy of Del Mar Thoroughbred Club.)

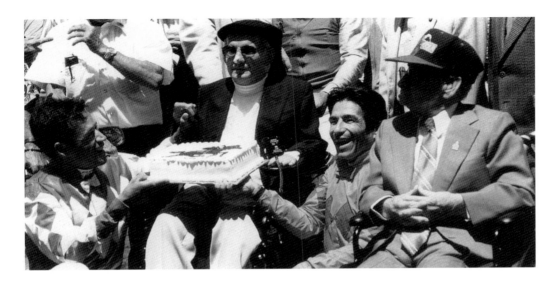

THIS CELEBRATION IS IN HONOR of Laffit Pincay setting a new record and surpassing the one held by William Shoemaker. Jockey David Flores, left, passes the celebratory cake across Bill Shoemaker to Laffit Pincay, the new champion, who jovially accepts it. John Longden sits and watches at far right. (Courtesy of Mr. and Mrs. Chase McCoy.)

JOHN LONGDEN IS PICTURED HERE leisurely relaxing on a friend's boat, the *Bandito*, en route to Avalon on Catalina Island. This photograph exemplifies that John was not all work but often had time for play. He enjoyed boating and especially liked cruising the waters between California and Catalina Island, where he could be involved in the sport of fishing. (Courtesy of Mr. and Mrs. Chase McCoy.)

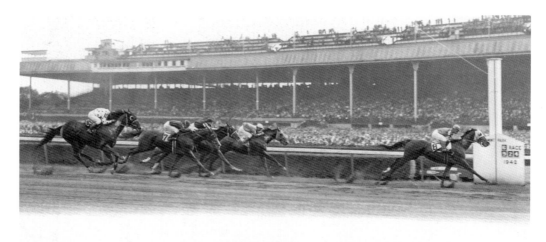

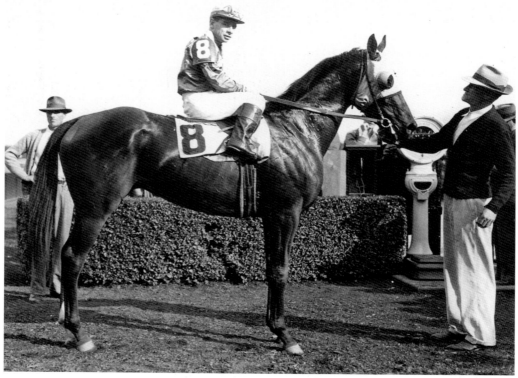

LEGENDARY JOCKEY JOHN LONGDEN is pictured sitting astride Count Fleet after winning the Morello Race at Belmont Park on September 14, 1942. He won the Kentucky Derby on Count Fleet in 1943. He retired in 1966 at the age of 59. His 40-year career totaled 34,413 mounts and 6,032 wins. He continued his success as a trainer until he retired and moved to Sun Lakes Country Club in Banning in 1990 with his wife, Kathy. He died at the age of 96 on February 14, 2003. (Courtesy of Mr. and Mrs. Chase McCoy.)

TAKEN IN THE JOCKEY ROOM, this photograph shows three well-known Thoroughbred racing jockeys that frequented the racing season at Del Mar. Pictured here, from left to right, are Alex Maise, Don Pierce, and John Longden. They all liked racing at Del Mar in the beach atmosphere where the turf meets the surf. (Courtesy of Mr. and Mrs. Chase McCoy.)

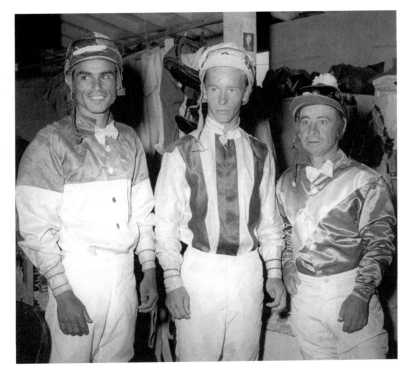

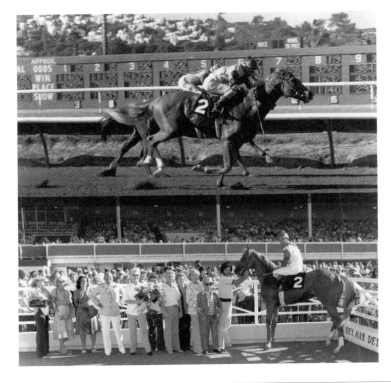

PICTURED HERE IS A Penny A Pitch, the horse that won the six-furlong, seventh race at Del Mar on August 8, 1979, with jockey Alex Maese. Judge Grey was second and Envoy's Agent third. The winner was owned by Mrs. John Longden and trained by her husband. Two familiar couples seen in the winner's circle are trainer Longden and his wife and Chase McCoy and his wife, Doris. (Courtesy of Mr. and Mrs. Chase McCoy.)

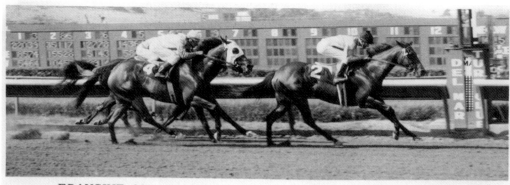

FRANCINE M. JOCKEY JOHN SELLERS
THE PALOS VERDES PENINSULA RAILWAY PURSE
Winner Fifth Race August 12, 1967 Purse $4000. Del Mar Turf Club
Luz Del Sol (2nd) 6 Fur. - 1:09.4 Alpine Peak (3rd)
OWNER: FRANK McMAHON, INC. TRAINER: JOHN LONGDEN

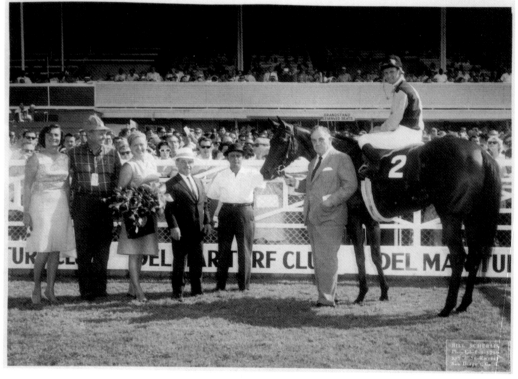

On August 12, 1967, the fifth race at Del Mar was the Palos Verde Peninsula Railway Race, a six-furlong trek that was won by Francine M. by a length, with jockey John Sellers aboard. Luz Del Sol and Alpine Pek were second and third, respectively. Francine M. was owned by Frank McMahon, Incorporated and trained by John Longden, who is standing in the winner's circle with his wife to his right. (Courtesy of Mr. and Mrs. Chase McCoy.)

SAN DIEGO COUNTY FAIR

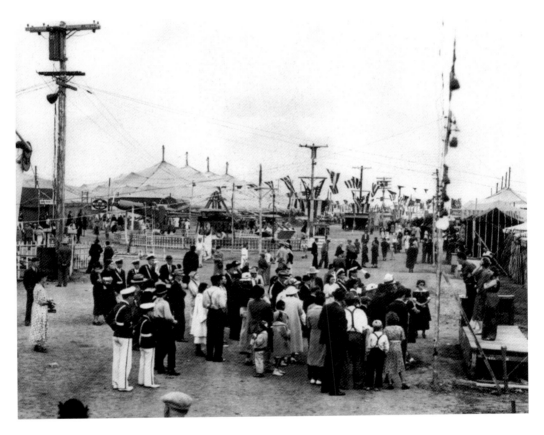

THIS PHOTOGRAPH DEPICTS the carnival presented at the first San Diego County Fair at the fairgrounds in Del Mar, which opened on October 8, 1936. One highlight of the fair was tightrope walker Bunny Dryden, who walked 110 feet above ground with his wife on his shoulders. There were numerous other attractions at that first fair. (Courtesy of Bill Arballo.)

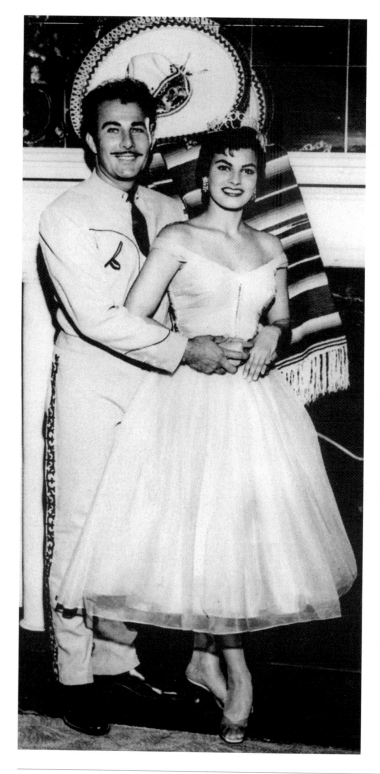

EACH YEAR, THE SAN DIEGO COUNTY FAIR has selected a queen. In this 1958 photograph, Raquel Tejada Welch, the "Fairest of the Fair" that year, is pictured with Don Diego (Tommy Hernandez), who traditionally escorted the queen each year. The role of Don Diego became a well-known entity during the San Diego County Fair presentation. (Courtesy of Bill Arballo.)

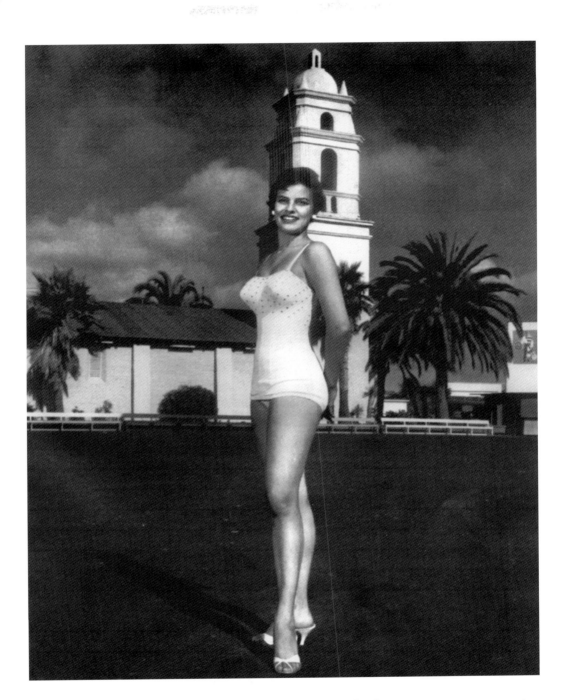

QUEEN RAQUEL TEJADA WELCH is pictured here after she won the title of Fairest of the Fair. It was, of course, a great honor to be voted this title at the San Diego County Fair, and consequently there were numerous entries. During the operation of the fair, the current queen received much publicity and became quite well known. (Courtesy of Bill Arballo.)

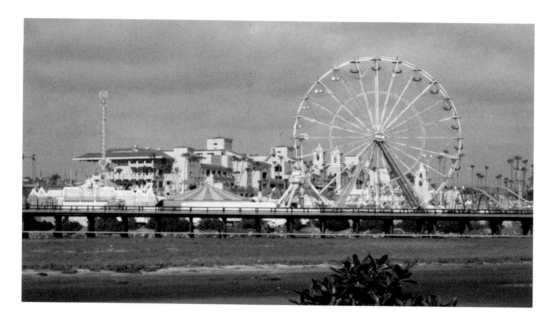

ONE OF THE MOST POPULAR EVENTS held each year at the San Diego County fairgrounds is the San Diego County Fair. Pictured here is a panoramic view of the west end of the Del Mar Stadium and Fairgrounds, where the large Ferris wheel was one of the main attractions in operation at the 2005 fair. (Courtesy of the author.)

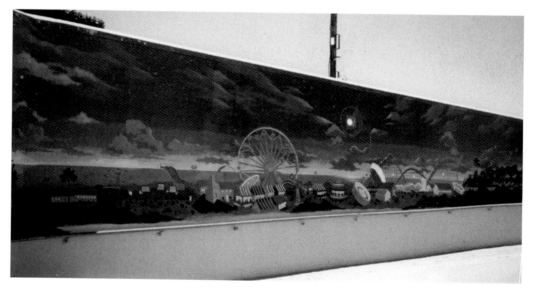

FERRIS WHEELS ARE ALWAYS a great attraction at fairs, and the one painted on the wall leading from the rear of the stadium to the infield in front is no exception. Many people passing the wall look at the scene and no doubt reminisce of their recent ride on the large Ferris wheel set up for this fair, which is a real joy. (Courtesy of the author.)

SAN DIEGO COUNTY FAIR

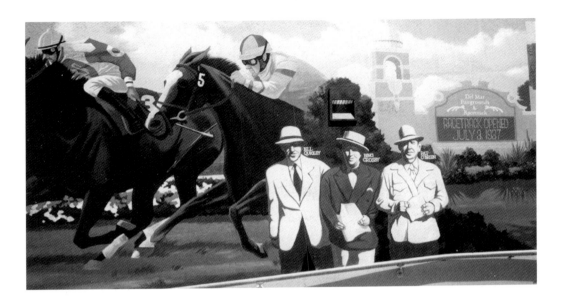

PAINTED ON THE WALL leading from the backside of the stadium to the infield, this mural portrayed the founders of the racetrack—Bill Quimbey, Bing Crosby, and Pat O'Brien. Participants of the fair can casually stroll along this wall and review the history of the racetrack. Note the date of it opening on July 3, 1937, to the right of the photograph. (Courtesy of the author.)

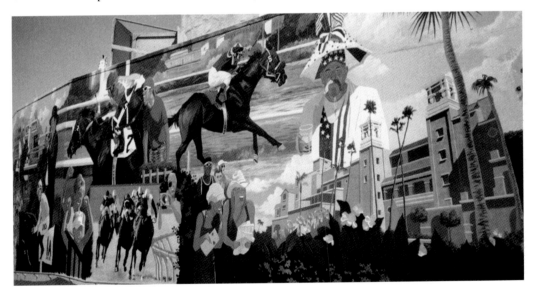

PICTURED HERE ON THE HIGH WALL between the infield and rear of the stadium is a large collage that shows racing, life, and good times at Del Mar. Although a permanent addition to the Del Mar grounds, when the San Diego County Fair is in operation, it adds much to the excitement of those admiring the fairgrounds. (Courtesy of the author.)

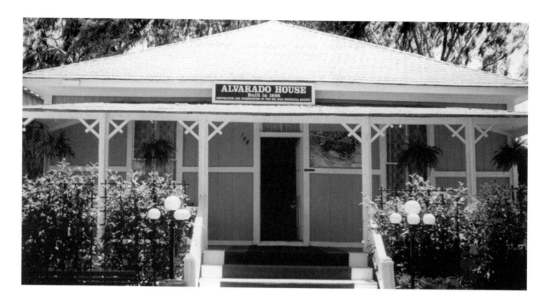

In 1886, this house was sold to Don Diego de Jesus Alvarado, owner of Rancho de Los Penasquitos. Acquired by the Del Mar Historical Society a century later, it was moved from its original location at 144 Tenth Street in Del Mar. The historic house is pictured here at its temporary site on the San Diego County Fairgrounds and is open during the fair and awaiting a permanent home. (Courtesy of the author.)

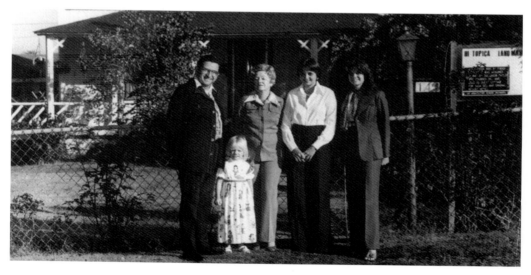

THE HISTORIC ALVARADO HOUSE was built in 1880 by Enoch Talbot and sold to Jacob Taylor, founder of the Del Mar Township, in 1885. From 1937 to 1976, it was occupied by the Arballo family. Pictured here, from left to right, are Bill Arballo, Del Mar's third mayor (1962–1963); a granddaughter; his wife Angelyn; and daughters Teresa Barth and Loreta Arballo. (Courtesy of Bill Arballo.)

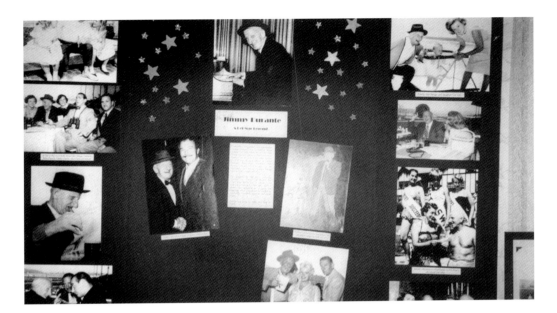

JIMMY DURANTE'S POPULARITY at the Del Mar Racetrack and in old town Del Mar can perhaps be estimated by these 12 photographs seen in this display at the Alvarado House during the fair season of the 2005 summer. He was a regular at the track and its press-club parties. He often climaxed his contribution by dismantling a trick piano. A nearby boulevard was named after him. (Courtesy of Del Mar Historical Society.)

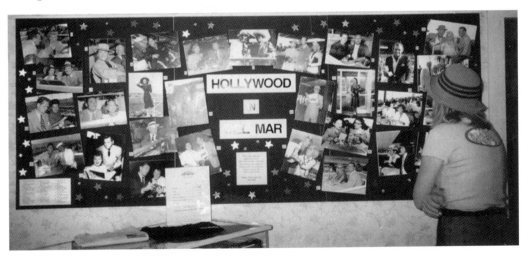

PICTURED HERE is an interested visitor at the Hollywood in Del Mar display at the Alvarado House during the San Diego County Fair in the summer of 2005. The display is a collage of celebrities who were lured to the Del Mar Racetrack, many of whom who made the town of old Del Mar their second stop. Several celebrities even purchased homes in the quaint little town. (Courtesy of Del Mar Historical Society.)

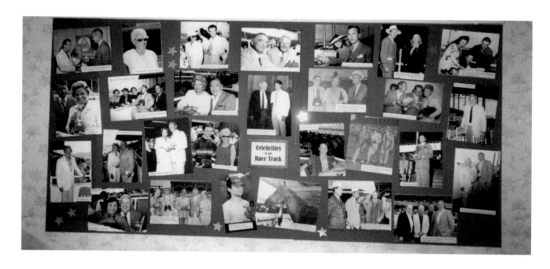

THIS DISPLAY IN THE ALVARADO HOUSE portrays numerous celebrities who have visited or become regulars at the Del Mar Racetrack throughout the years. The display celebrates a reservoir of show-business members with related talents who have reached pinnacles that would be hard to match. Each photograph reveals a story revolving around celebrity persons of prominence. (Courtesy of Del Mar Historical Society.)

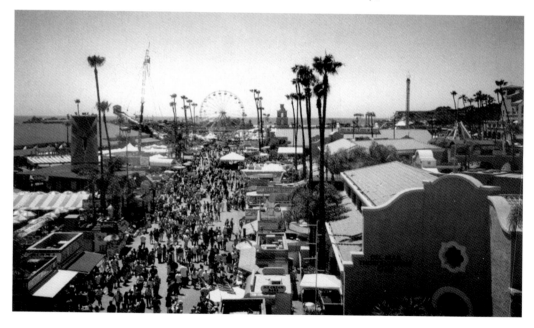

A FULL-CAPACITY CROWD visits the San Diego County Fair at the Del Mar Racetrack, seen from the Sky Ride that ascends above the track's buildings and transverses its grounds. The sea of people below fill the fairway that leads from the front entrance of the grounds to the large Ferris wheel at the far end. (Courtesy of the author.)

SAN DIEGO COUNTY FAIR

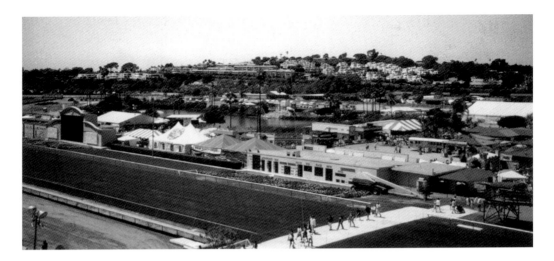

THIS PHOTOGRAPH WAS TAKEN during the 2005 San Diego County Fair from atop the Sky Ride. The center infield is filled with tents and kiosks that venders brought in and set up. A walkway has been placed over both the turf track and the regular dirt track, establishing a walkway for visitors to travel from stadium grounds to the center infield. (Courtesy of the author.)

A GROUP OF PARTICIPATES enters the Del Mar Fairgrounds for its yearly event in 2005. Since its meager inception in 1936, it has continued for almost seven decades to be an intrepid attraction in San Diego County and the city of Del Mar. Visitors await a gala event inside, with numerous exhibits, rides, and entertainment for all. (Courtesy of the author.)

THIS LIFE-SIZE STATUE of Don Diego stands at the entrance to the Del Mar Racetrack on the San Diego County Fairgrounds. Standing high on a pedestal and exuberantly waving his hat, his engraved greetings—*Bienvenitios Amigos*—welcome all. He was the goodwill ambassador of the Del Mar Fair from 1947 to 1954 and the magical figure who appeared each year to escort the Fairest of the Fair to preside over the Del Mar Fair. Tom Hernandez later served as the official host of the Del Mar Fair, Southern Exposition, portraying Don Diego for 37 years. (Courtesy of the author.)

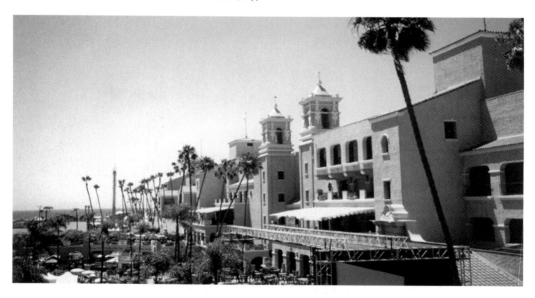

THIS IS ANOTHER SKY RIDE VIEW of the backside of the Del Mar Racetrack stadium, looking west and bringing into view a glimpse of the blue Pacific. No wonder Bing Crosby's legendary ditty is heard twice a day, every day, all season long. For many a visitor, hearing this song at the beginning and end of the racing day adds flavor to the visit. (Courtesy of the author.)

FROM THE SKY RIDE ATTRACTION at the San Diego County Fair, this is a view of the Del Mar Stadium. It offers a glimpse into the grandstand area that normally is not seen from ground level. It is literally surrounded with fair goers and exhibitions adorn its inside halls. (Courtesy of the author.)

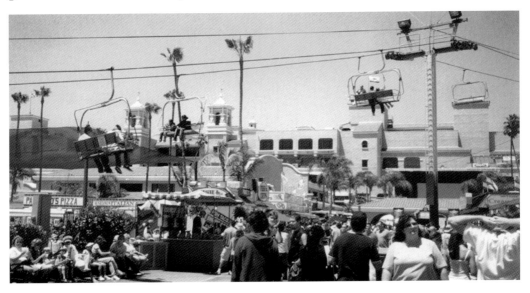

A PORTION OF THE LONG SKY RIDE, extending from the track's infield to the rear of the stadium, is pictured here with a number of riders enjoying the view in the cradled chairs suspended from cables. The Sky Ride is a very popular attraction at the fair because it provides an overall view of the track that is not normally seen. (Courtesy of the author.)

BING CROSBY HALL was built under Bing Crosby's administration and is a landmark on the San Diego County Fairgrounds. It is the third largest of the indoor exhibit buildings, measuring 319 feet by 100 feet, with a ceiling height of 24 feet. Its important use during San Diego County fairs perhaps cannot be overemphasized, for it can facilitate 150 10-foot by 10-foot booths, or 3,500 people. (Courtesy of the author.)

PICTURED HERE is the entrance to Del Mar Horsepark, a 65-acre, world-class equestrian facility. In 1994, the park was purchased by the 22nd District Agricultural Association (DAA), also referred to as the Del Mar Fairgrounds, and it added another important event facility to the fairgrounds. Del Mar Horsepark was honored to have been selected as the site for the 2000 U.S. Olympic jumping trials. (Courtesy of the author.)

THE ARENA AT THE DEL MAR HORSEPARK is a grand-prix field that contains 1,400 permanent seats, with additional capacity for up to 8,000 spectators. The park is owned and operated by the DAA. Thoroughbred auctions used to be held yearly at the Surf Building on the fairgrounds near the racetrack. When moved from there, it was once held at the Del Mar Horsepark, then elsewhere. (Course of the author.)

PICTURED HERE is one of several training areas that are available at the Del Mar Horsepark. Permanent box and pipe stalls are available for year-round horse boarding and there is qualified professional training for all levels of event participation. The facility is located 1.4 miles east of the Pacific Ocean and 20 miles north of San Diego. (Courtesy of the author.)

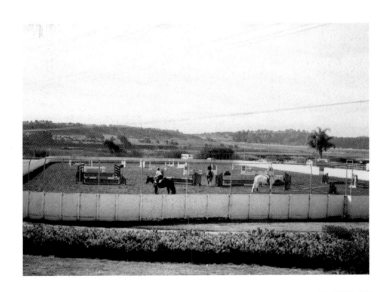

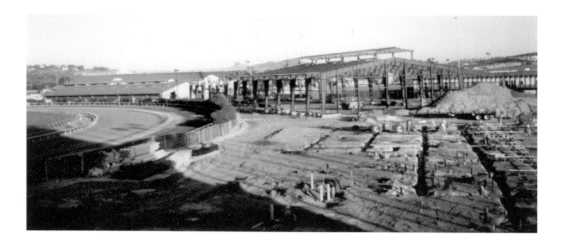

RECENTLY THE DEL MAR FAIRGROUNDS have razed three old barns in order to make room for two larger and more modern structures at the fairgrounds. The three outdated barns were over 50 years old, and a public demolition ceremony was held before they were destroyed. The new 80,000-square-foot, multipurpose facilities, pictured here under construction, will be used for livestock, exhibitions, conventions, and events. (Courtesy of the author.)

THROUGHOUT THE YEAR, numerous events are presented at the San Diego Fairground. Pictured here is the big top circus tent of Cirque du Soleil, which returned to present *Quidam*, a show of inspiration and emotion. Since its inception in 1984, Cirque du Soleil has performed shows in 100 cities and about 18 countries. It has a collection of 56 cast performers and 135 crew members. (Courtesy of the author.)

5

DEL MAR
RACETRACK'S NEIGHBOR
OLD DEL MAR

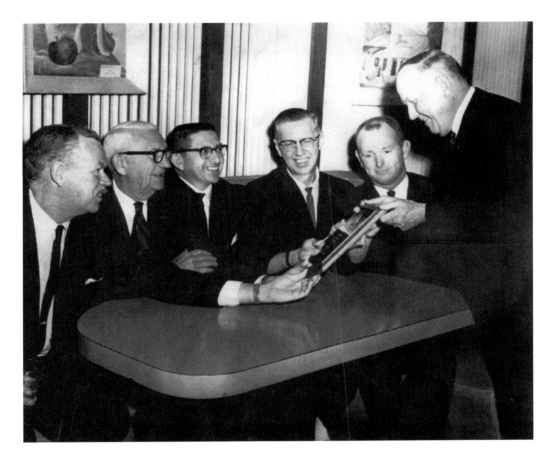

DEL MAR'S FIRST FEW MAYORS, from left to right, are Tom Douglas (1959–1960), Tom Barr (1960–1962), Bill Arballo (1962–1963), Victor Koss (1963–1964), and Earl Maas Jr. (1964–1968). Also pictured, standing at far right, is Stud Green, Del Mar's first chamber of commerce president (1946–1949). (Courtesy of Bill Arballo.)

THIS UNIQUE COTTAGE was built in 1912 by William English Hyer for noted photographer Oscar Mauer. It was originally located on the southwest corner of Fifteenth Street and Camino Del Mar. The house and garage were moved to this location at 1431 Stratford Court, Del Mar, in 1927. Today it is a landmark in the community known as the Mauer House. (Courtesy of the author.)

THIS IS A RECENT PHOTOGRAPH of the Edelweiss House, located at 227 Tenth Street in Del Mar. Built in 1885, it stood for years shaded by Torrey pines. The Torrey pine is one of the world's rarest trees (actually thought to be a carryover from the Ice Age) and is grown naturally only two places in the world—Torrey Pine State Reserve and on Santa Rosa Island. Today this house is a community landmark. (Courtesy of the author.)

ON THE NORTHEAST CORNER of Sixteenth Street and Highway 101 is the frontage of Del Mar Plaza. Located on the upper level are numerous shops and three popular restaurants—the Pacifica Breeze, Epa Zote, and El Toraio. The popular eateries are favorite gathering places to watch beautiful sunsets from their patios, with customary hand clapping once the sun demises below the ocean's horizon. (Courtesy of the author.)

THE DEL MAR LIBRARY was constructed in 1914 as St. James Catholic Church. Parishioners included Jimmy Durante and Desi Arnaz. Bing Crosby and Pat O'Brien served as ushers. The church moved to Solana Beach and the building remained, which became the Albatross Restaurant before being sold to the City of Del Mar in 1990 and restored as a public library, winning a 1997 award for historic preservation. (Courtesy of the author.)

THE ROCK HAUS, at 410 Fifteenth Street, is a familiar landmark in Del Mar. In the past, it had long been a landmark known as the Keller House. In 1981, it became the Rock Haus when Tom and Carol Hauser bought and converted it to a bed-and-breakfast inn. It is one of many vintage images in the collection of the Del Mar Historical Society's photograph section. (Courtesy of the author.)

NINETEEN HUNDRED AND TWENTY NINE was the year of the great stock-market crash and essentially the beginning of a long depression, but the vigorous economy and real estate boom that preceded this era brought much building activity to the southern coastal California towns. Del Mar was no exception. This string of cottages, still present today, was built in 1929 at the end of Tenth Street, luring tourists to Del Mar's inviting beach. (Courtesy of the author.)

HERE IS THE ENTRANCE to Bully's North, a popular cocktail tavern and eatery at 1404 Camino Del Mar in Del Mar since 1969. Bully's North was named after one of its founding partners, George Bullington. Today it is owned by Beverly Yuhause Becker, who has maintained its pub-like atmosphere and its track heritage of paintings on its walls. (Courtesy of the author.)

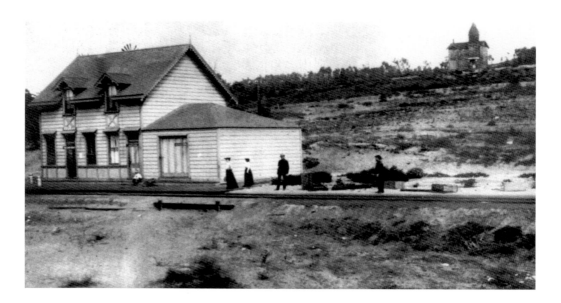

THIS IS AN EARLY PHOTOGRAPH of the first train station in Del Mar, located on Stratford Court. Note the windmill blades that protrude above the station's roof ridge and barren hillside in contrast to the large buildings seen there today. Farther above, on the ridge at right, is the Victorian elementary schoolhouse, with its bell tower plainly seen on the horizon. (Courtesy of Bill Arballo.)

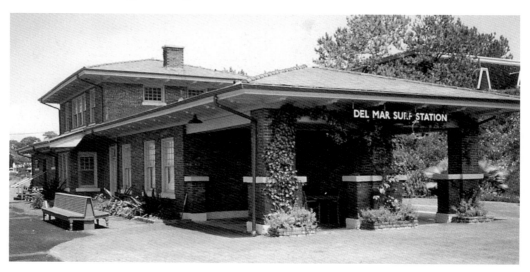

PICTURED HERE is the old Del Mar Surf Station that replaced its old wooden predecessor, and although inactive today, it remains a great landmark. It was allegedly closed due to limited parking space in the confined area, which was not required when it was originally built. Nearby Solana Beach and Encinitas (to the north) both have modern train stations. (Courtesy of the author.)

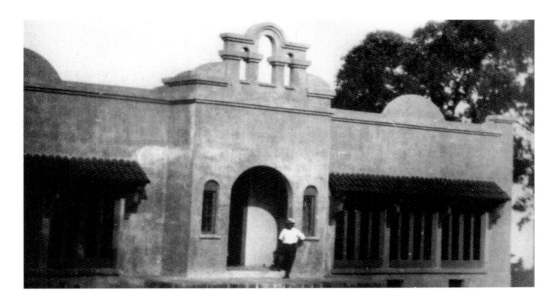

DEL MAR'S SECOND ELEMENTARY SCHOOL was St. James Academy. It opened in September 1921 as a two-room schoolhouse, although initially there were so few pupils they used only one room with one teacher. It is currently used as Del Mar's city hall, having remained on the west side of Tenth and Eleventh Streets on Westside Camino del Mar. (Courtesy of Bill Arballo.)

IN 1908, the old Victorian schoolhouse on the hill had only an average daily attendance of 11 students and, in 1911, just 25. In 1919, the decision was made to vacate the 34-year-old schoolhouse and build a new one. Before that, though, the class was held in a dance hall on the bluff where Seagrove Park is now located. This 1939 photograph shows students at the new school on Camino del Mar. (Courtesy of Bill Arballo.)

PICTURED HERE IS THE CASTLE, a treasured landmark of Del Mar, located on Avenide Primavera. It was built as a private residence in 1926–1927 by Marsten Harding. It is probably commonly referred to as The Castle because the living room was copied from the San Simeon's Hurst Castle. Its beams and doors are from a real castle in Spain. (Courtesy of the author.)

DEL MAR'S POWERHOUSE COMMUNITY CENTER was built in the early 1900s and renovated in 1999 with a major face-lift. It is pictured here with the landmark smokestack, once used for power, behind it. A plaque credits the center to Fletcher family members and a friend and dedicates it in loving memory to Richard Lee Fletcher and Eugene B. Fletcher. It reads, "They Loved the Sea and They Loved Del Mar." The center is the site of numerous community events. (Courtesy of the author.)

STRATFORD SQUARE, the brick and beam Tudor building pictured here, is located in the heart of Del Mar's village. This historical landmark was built in 1909, originally known as Stratford Inn. Today it is one of the commercial buildings in Del Mar. The large resort hotel, at that time, got its energy needs from the powerhouse on Coast Boulevard, a short distance away and now a community center. (Courtesy of the author.)

CONSTRUCTED IN 1960, the Del Mar Beach lifeguard headquarters, left, sits next to the Poseidon Restaurant, at right, with its outside beach patio. To its right is Jakes Del Mar Restaurant, which began as the Stratford Inn Garage on the beach that was later revamped into the Stratford Restaurant. The Powerhouse Civic Center's tower is seen in the center. (Courtesy of the author.)

Across America, People are Discovering Something Wonderful. *Their Heritage.*

Arcadia Publishing is the leading local history publisher in the United States. With more than 3,000 titles in print and hundreds of new titles released every year, Arcadia has extensive specialized experience chronicling the history of communities and celebrating America's hidden stories, bringing to life the people, places, and events from the past. To discover the history of other communities across the nation, please visit:

www.arcadiapublishing.com

Customized search tools allow you to find regional history books about the town where you grew up, the cities where your friends and family live, the town where your parents met, or even that retirement spot you've been dreaming about.

MAP SEARCH